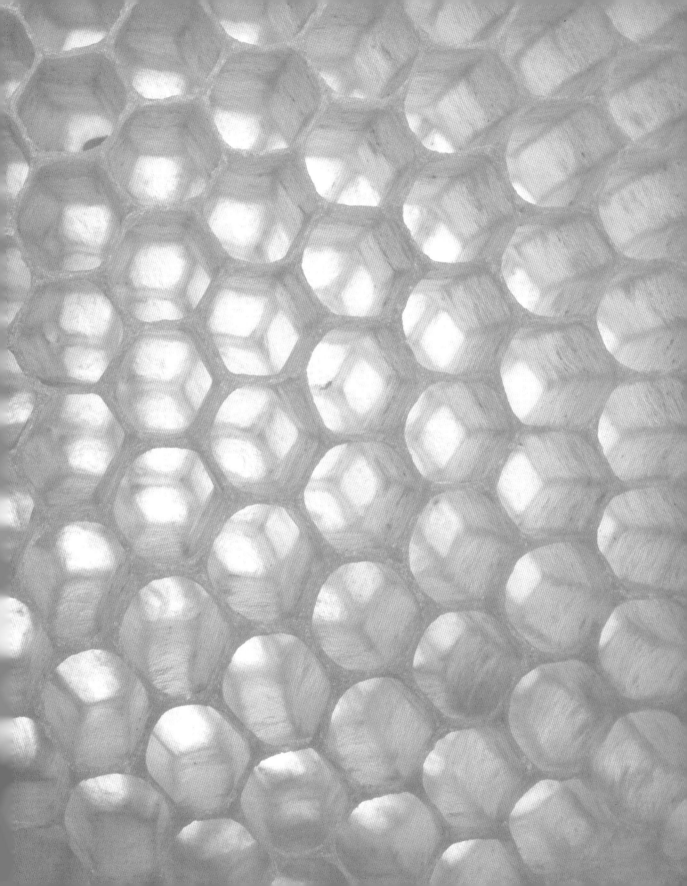

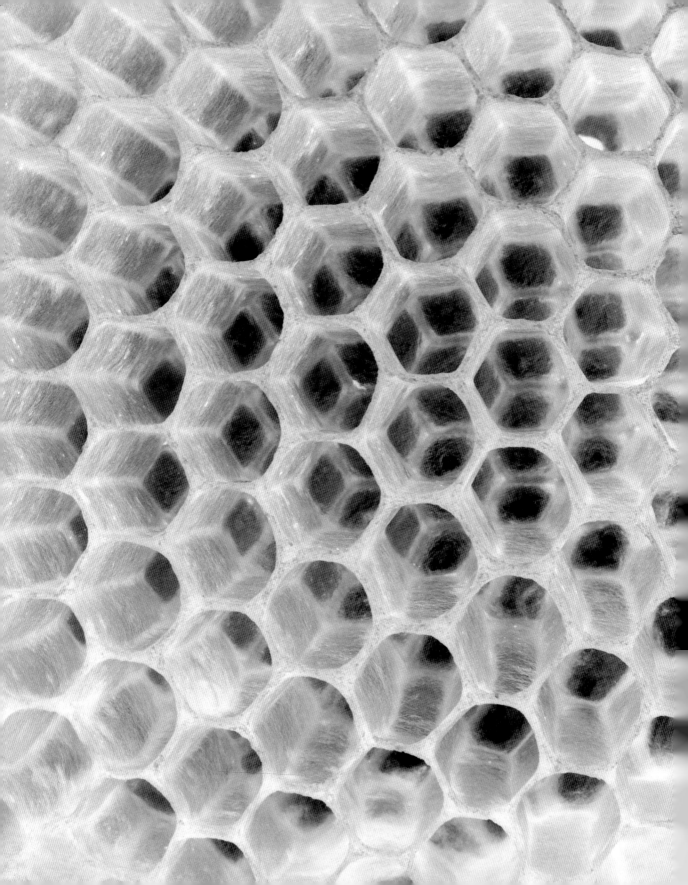

BEE

photographs by

Rose-Lynn Fisher

foreword by

VERLYN KLINKENBORG

Princeton Architectural Press · New York

Published by
Princeton Architectural Press
37 East 7th Street, New York, NY 10003

For a free catalog of books, call 1-800-722-6657
Visit our website at www.papress.com

This publication was made possible with funding
from Howard Stein.

Editor: Jennifer Thompson
Designer: Paul Wagner

Special thanks to: Nettie Aljian, Bree Anne Apperley,
Sara Bader, Nicola Bednarek, Janet Behning, Becca Casbon,
Carina Cha, Tom Cho, Penny (Yuen Pik) Chu, Carolyn Deuschle,
Russell Fernandez, Pete Fitzpatrick, Wendy Fuller, Jan Haux,
Clare Jacobson, Linda Lee, Laurie Manfra, John Myers,
Katharine Myers, Dan Simon, Andrew Stepanian, Joseph Weston,
and Deb Wood of Princeton Architectural Press
—Kevin C. Lippert, publisher

Library of Congress Cataloging-in-Publication Data
Fisher, Rose-Lynn, 1955-
Bee / photographs by Rose-Lynn Fisher ; foreword by
Verlyn Klinkenborg.
 p. cm.
ISBN 978-1-56898-944-0 (alk. paper)
1. Honeybee—Pictorial works. 2. Honeybee. I. Title.
SF523.7.F57 2010
638'.120222—dc22
 2009046035

Contents

FOREWORD 9
Verlyn Klinkenborg

BEEyond 13
Rose-Lynn Fisher

PLATES

antenna 17

body 37

eye 59

leg 71

proboscis 83

wing 99

ACKNOWLEDGMENTS 128

SOURCES 128

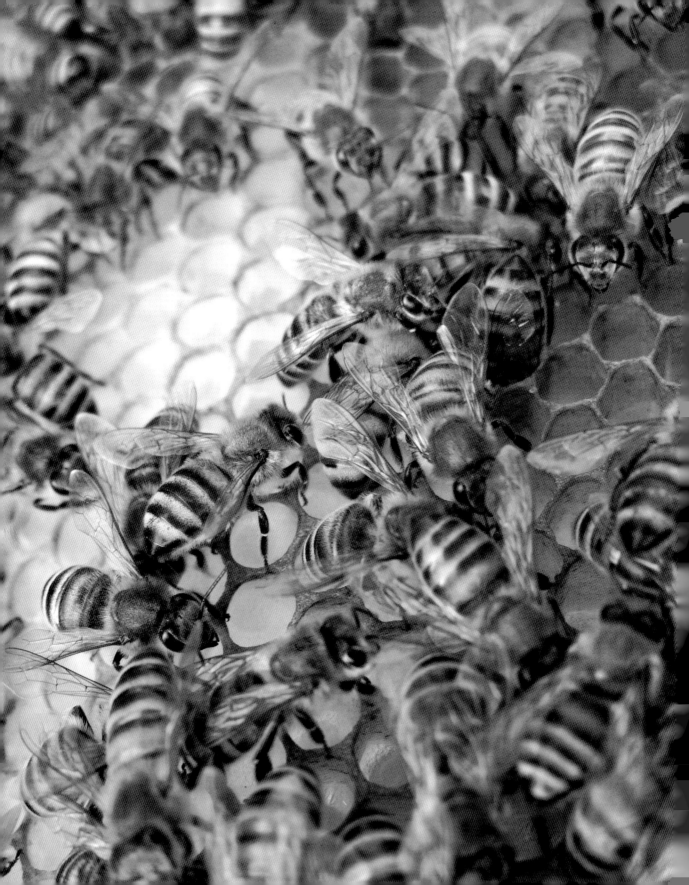

To the honeybees,
who nourish and inspire,
may you thrive.

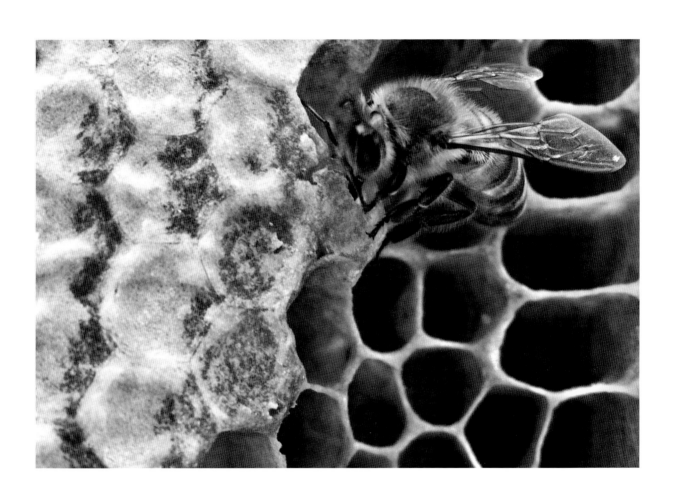

A lone feeding honeybee

I suffer a sort of species envy around honeybees. Not that I want to belong to the tight sisterhood of workers or be the only thing a male bee can be—a drone. Nor do I aspire to royalty. Who would, after watching the queen at work?—cosseted, spoon-fed, but really a prisoner of her ovaries, closely guarded, held to her task, doomed to be the victim of a kind of reproductive regicide by laying herself to death over the years.

No, the envy I feel is about purpose. We all know about the legendary, the platitudinous industry of bees, though they also spend plenty of time resting in the hive. The busyness we attribute to bees is both social—the collective enterprise of the colony— and individual. But as Rose-Lynn Fisher's photographs suggest, it goes even deeper than that.

When I look at the bees in my hive—warm, brown, Italian—I think of them, somehow, as furred. But Rose-Lynn Fisher's photographs, taken under a scanning electron microscope, make it clear that the worker bee is barbed, spiked, scaled, serried, bristled, and externally cactused. None of this is defensive, apart from the stinger, which is really a modified *ovipositor*. Whatever her immediate task is out in the world—gathering nectar or *propolis* (a gummy substance collected from the resins of trees and flowers), drinking water, making her way to and from the hive—she is always passively, but not incidentally, capturing grains of pollen with her body. Pollen, of course, is the living male germ of the flower and the proteinaceous food needed for growing new bees. The bee winnows every plant she touches. She winnows the very air.

In other words, there's nothing general about a honeybee. In design, she's a conspiracy of the pollen-bearing plants of the temperate world, many of which bait themselves with bee-attracting nectar for the sole purpose of distributing their pollen on the bodies of bees to the stigmas of other plants of their kind. If a honeybee ever happened to wonder about her purpose in life— which is the sort of thing only humans do (generalists all of us)— she would find immediate reassurance in the specialization of her bodily architecture.

There are, for instance, the pollen brushes on her hind legs, for cleaning pollen from her haired eyes and her head and mouth. There are the pollen rakes and the pollen presses—also on her hind legs—designed to help transfer pollen from the brushes to the pollen baskets on her tibia.

And then there are her miraculous antennae. One of the hardest things about understanding other species—really grasping their worlds—is understanding the differences between our sensory apparatus and theirs. Because you have a nose, you may think you can imagine what it would be like to have your dog's keen sense of smell. But in fact you can't. How much harder, then, to guess at the world the honeybee knows by means of instruments we don't possess?

We think of antennae as unitary things—stems receiving a "ping" of sorts from the world around them, like rabbit ears on an old TV or the RKO Radio Picture logo. But the bee's antenna is a complex and sophisticated apparatus. Each one has thousands of receptors—pegs and pores and pits and hairs—for discerning taste, touch, hearing, smell, even the speed of flight. Her antennae allow her to locate the direction of a scent and its intensity, to smell carbon dioxide—critical for regulating the atmosphere of the hive—and, above all, to read and write the complex pheromonal language of the colony.

And if these external structures weren't enough to persuade a worker of her purpose in life, she might also look inward. She is, in fact, a flying biochemical factory. She can store honey and nectar and water in her alimentary canal for the use of other bees. She's fitted with wax glands, which secrete small flakes of wax that she, aided by the saliva from special glands in her head, works into hexagonal cells. Other specialized head-glands produce enzymes that help convert nectar into honey. The complex *pheromones* emitted by her *Nasonov gland*—which she exposes by angling her abdomen upward into the air—help orient bees to the hive and to sources of water. She has an unusual sensitivity to magnetism, which helps her build vertically true honeycombs in the darkness.

In fact, as you look closer at the physiology of the honeybee, you realize how utterly and completely she is adapted to adapting the world around her. She converts nearly every substance she comes upon to the needs of the hive. Pollen is altered to keep it from germinating and to prepare it for feeding and storage. Her own secreted wax is softened and turned to honeycomb. She converts the sugars in nectar and slowly evaporates it into ripened honey. She manipulates propolis into a glue that helps seal the hive. The temperature and oxygen content in the hive are carefully controlled by clustering and fanning. In a very real sense, there's nothing raw in a beehive—nothing that's not being altered by workers to their own needs.

And that includes themselves. Unlike some species of ants and termites, which are divided into rigid castes, a worker bee usually performs many different kinds of tasks—cleaning the hive, carrying out the dead, building cells, capping cells, feeding pupae, attending the queen, gathering pollen and nectar and water, raising alarms, defending the hive, ventilating the hive, and performing the extraordinary bee-dances that are (along with pheromones), the essential language of the colony. To a large extent, these tasks are distributed by age groups—younger bees clean and cap cells, for instance, while older ones forage for pollen and nectar.

But as bees age through their tasks, they undergo significant internal changes. Their glands alter, some growing into prominence, some dwindling and being resorbed by the body. This happens, for instance, as young bees shift from handling wax to handling food for immature bees in brood-cells. It happens as they take up guard duty or begin foraging. Most bees in the hive literally change their nature as they change their task, including the small percentage of workers who retain the ability to lay eggs— a necessary backup in case the queen begins to fail in her duties. The youngest work, the oldest work, and the oldest differ from their younger selves almost as much as they differ from the queen or from all those pupae lying folded in their cells, waiting to emerge into a world to which they are perfectly fitted.

I stand beside my hive again and again in late summer—stand in
the complex scent that a healthy, working colony gives off. The
scent is part honey and wax, of course, but I wonder sometimes
if I can't also smell the chemical language being spoken inside.
I will never get used to opening the hive. I search for the queen,
look for the number and pattern of brood-cells—where young bees
are being raised—and of course I look to see how many frames are
filled with honey. I pry apart the propolis-sealed frames and look
too for the pollen-stores—the cells where pollen has been packed
in tight. And all the while the bees go about their business,
looking indistinguishable from each other, as if each worker were
the exact replica of every other worker. They do share the vast
majority of their DNA, after all.

But they're not indistinguishable, even if their individual
differences are indiscernible to a casual observer like me. In a
way, the only good metaphor we have for the hive is the hive itself.
Our metaphors are too rich with human association, sometimes too
complex, sometimes too simple to really capture the essence of the
hive, the balance between individual and collective. The hive is
not a machine or a city. It's a society or a community mainly in its
collective sense. It's not really a guild, though it has guild-like
qualities. If it's a monarchy, it's a highly paradoxical monarchy—
absolute and somehow constitutional at the same time.

So let me speak of it without metaphor. A bee-hive is one of the
most successful ways in which the purpose of life has ever been
organized. It's so well organized that you can almost detect the
purpose of life as you stand in the honey-drift downwind. The bees
rise and fall in front of the entrance like a cloud of atoms, each
of them shaped—right down to the hairs on their tongues—by the
overwhelming purpose of the hive. I feel that if I just stand here
long enough—watching the bees land at the hive entrance, watching
them dance in their minute shadows thrown by a warm sun overhead—
then perhaps I'll understand the purpose of life too.

BEEyond / Rose-Lynn Fisher

The first time I looked at a bee's eye magnified I was amazed
to see a field of hexagons, just like honeycomb. I wondered, is
this a coincidence or a clue? Is it simply that hexagons are
ubiquitous in nature, or is there a deeper connection between the
structure of the bee's vision and the structure she builds—in
other words, corresponding frequencies expressed in corresponding
forms? This got me pondering on the relationship between vision
and action at a more abstract, metaphoric level. Could there
be a parallel kind of encoding relevant to humanity? At a refined
level of human nature, is our deeper capacity for vision and
action in alignment with an intrinsic structuring?

As though revealing a secret, the scanning electron microscope
presents a realm of structure, design, and pattern at a level
of intricacy we are oblivious to in our daily experience. In
this bizarre frontier, our sense of scale is confused, and
connections between the micro and macro world become clearer
and more tangible. In the myriad forms that constitute one little
bee at higher and higher magnifications, there is a hint of the
unending complexity of nature, the worlds within worlds comprising
our reality. And then the realization—we are part of all this,
too! It's enough to rouse a mind to challenge itself, inspiring
our best blend of observation and imagination, and apply it to
making a better world.

While we now have easy access to powerful microscopes, history
is dotted with people whose curiosity and brilliance surpassed
technological limitations of their day. One was Jan Swammerdam
(1637-1680), a Dutch natural scientist and mystic who designed a
single lens microscope with magnifications up to 150x to view and
dissect insects. He was the one who clarified that the king bee
was, after locating her ovaries, a queen. His observations and
drawings were at the foundation of establishing the field of
entomology. His opus, *Bible of Nature*, posthumously published
in 1737-8, is still a source for modern knowledge about insects.

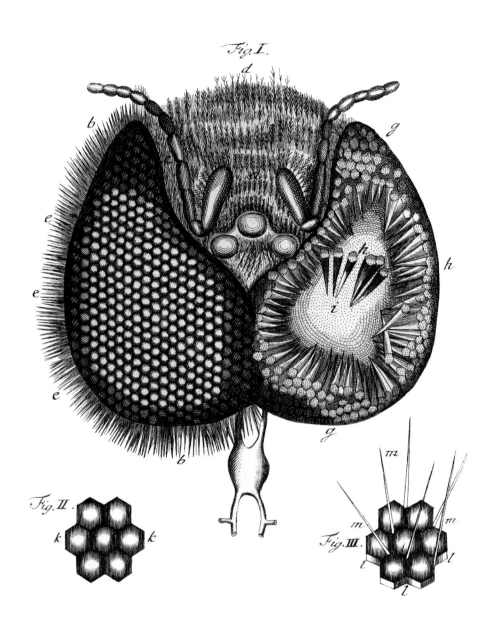

Jan Swammerdam's copper-plate
engraving of a drone's head, showing
compound eyes in great detail, as seen through
his microscope. From his *Bible of Nature*.

Our most important pollinator, the ultimate synergist, an architect, spatial genius, winged apothecary, and the transmuter of the finest substance of nectar into honey, the honeybee has been revered and utilized by civilizations throughout time. Our own sustenance depends on bee pollination for one third of what we eat. The plight of bees due to colony collapse disorder, mites, pesticides, habitat loss, and other issues is making us wake up to their needs and their necessity to us; to take responsibility for restoring and protecting their health.

Honeybees live in a peaceful society whose industries benefit life. How can we emulate their example of harmlessness and beauty? For me, the honeybee symbolizes and embodies a congruency of form and function, vision and action, spirit and matter, all being of the same essence. I offer these photographs in celebration, respect, and gratitude for all that they do and are.

antenna

The antennae are the sensory organs of the bee for smelling, tasting, and hearing, as well as detecting changes in temperature, vibration, wind, and humidity. There are a variety of pore sensilla (sense cells) in the form of craterlike plates, pits, and pegs of hair.

antenna sockets 43x

Set into sockets on the head, the antennae
pivot with a free range of motion. The base
of the antenna projecting from the socket
is called the *scape*. The area of the head above
the antennae is the *frons*. The area below the
antennae is the *clypeus*, which leads into
the *labrum*, the upper lip.

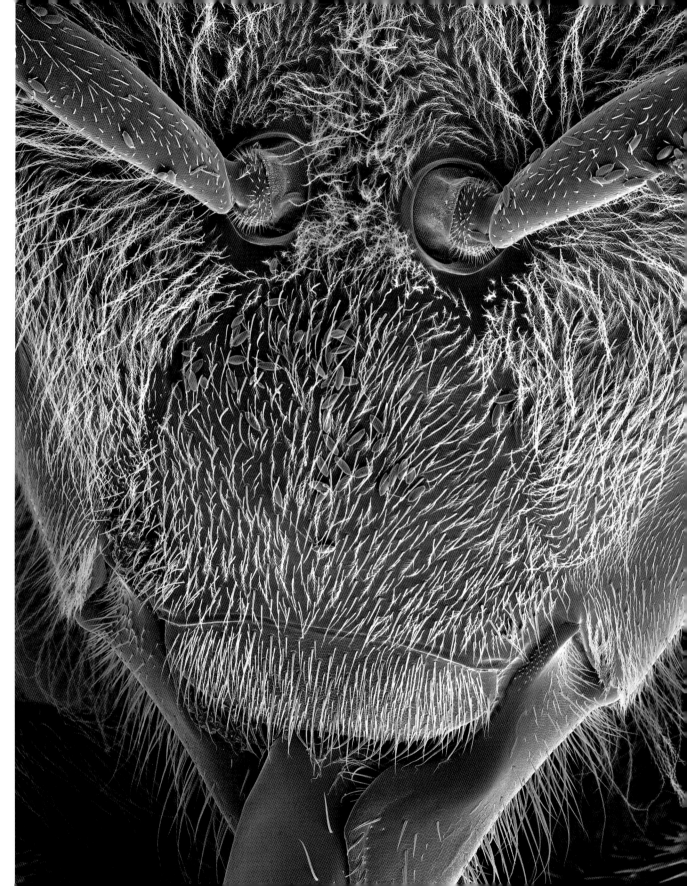

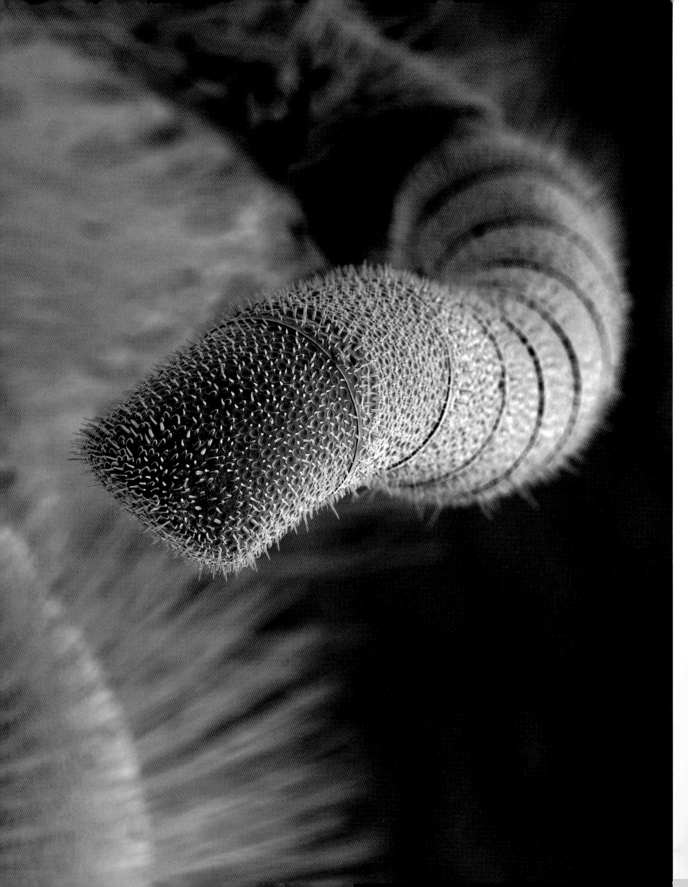

antenna 130x

The front section of the antenna is the
flagellum. It is connected to the scape at the
pedicel. The flagellum is made up of ringed
subdivisions, providing flexibility in movement
so that the bee can pick up sensory signals
all around.

antenna 150x

Side view showing the three segments
of the antenna: the scape (with pollen),
the knob-shaped pedicel, and flagellum.
The pedicel contains auditory sensilla.

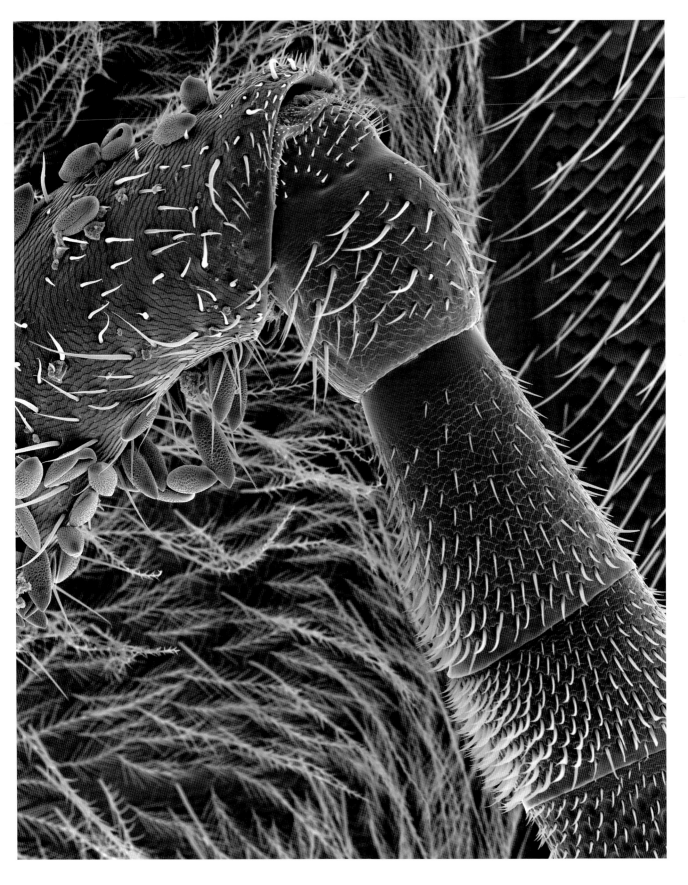

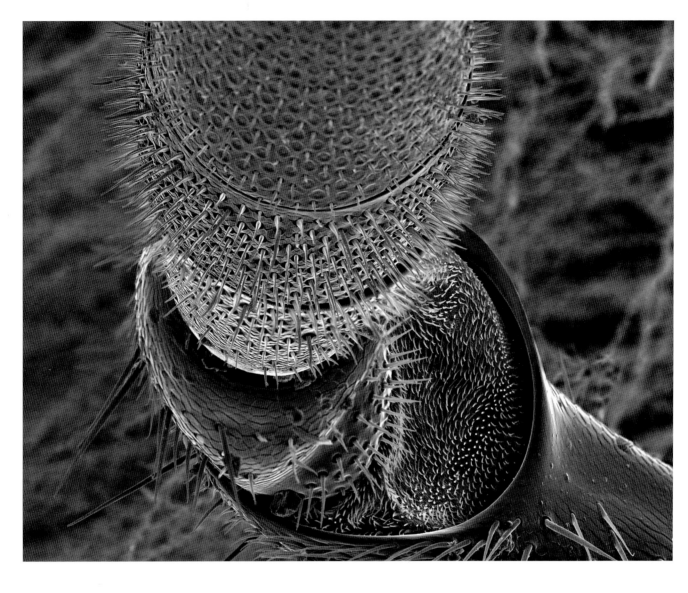

antenna 270x (above)

The articulation of the scape, pedicel, and flagellum

antenna 270x (opposite)

The terminal end of the antenna is flat on one side.

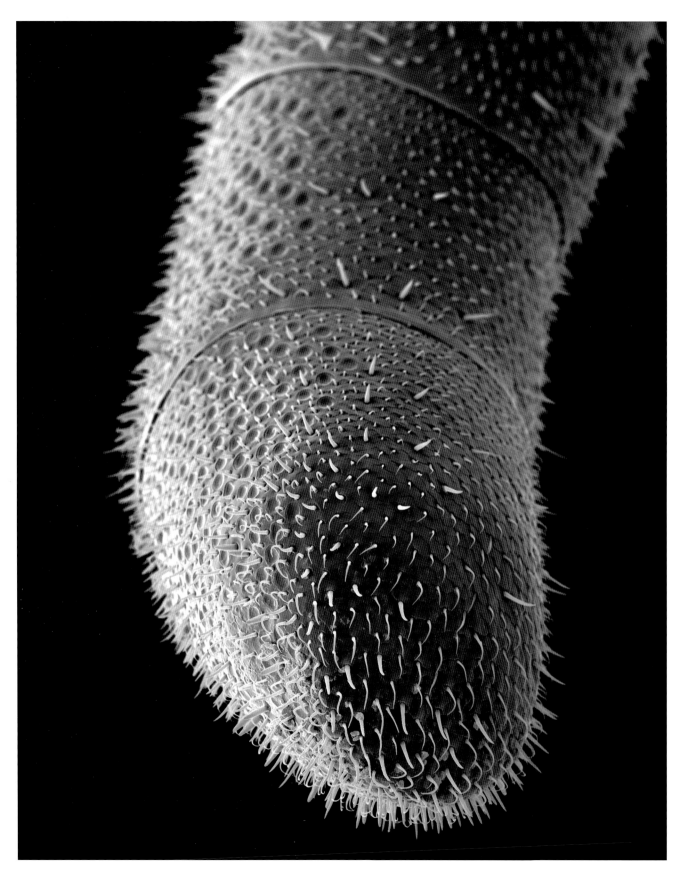

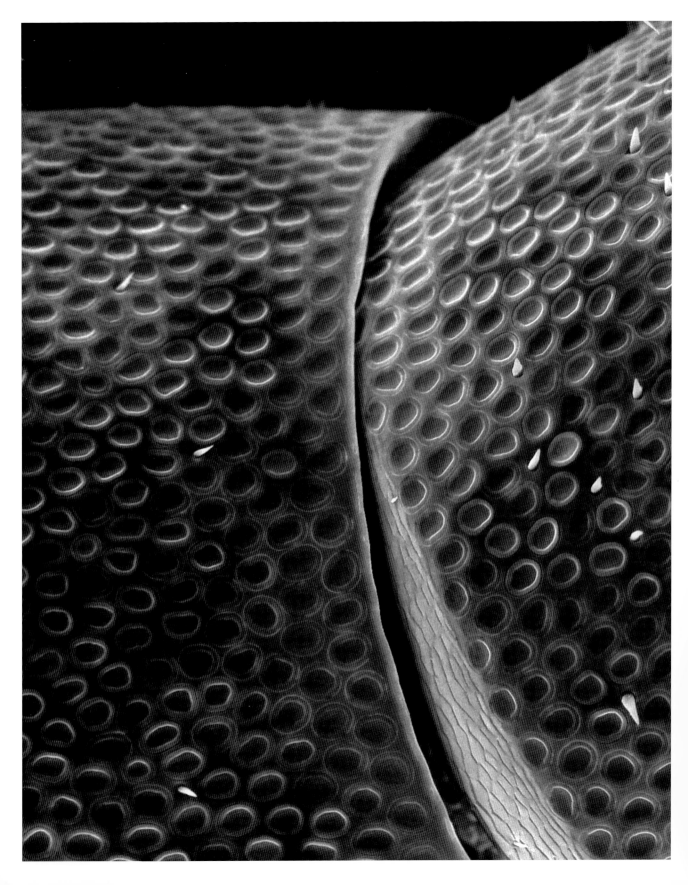

antenna 400x

Each *flagellomere* (ringed subdivision of
the flagellum) fits into the cavity of the
one next to it.

antenna 900x

Plate and peg sensilla of the flagellum

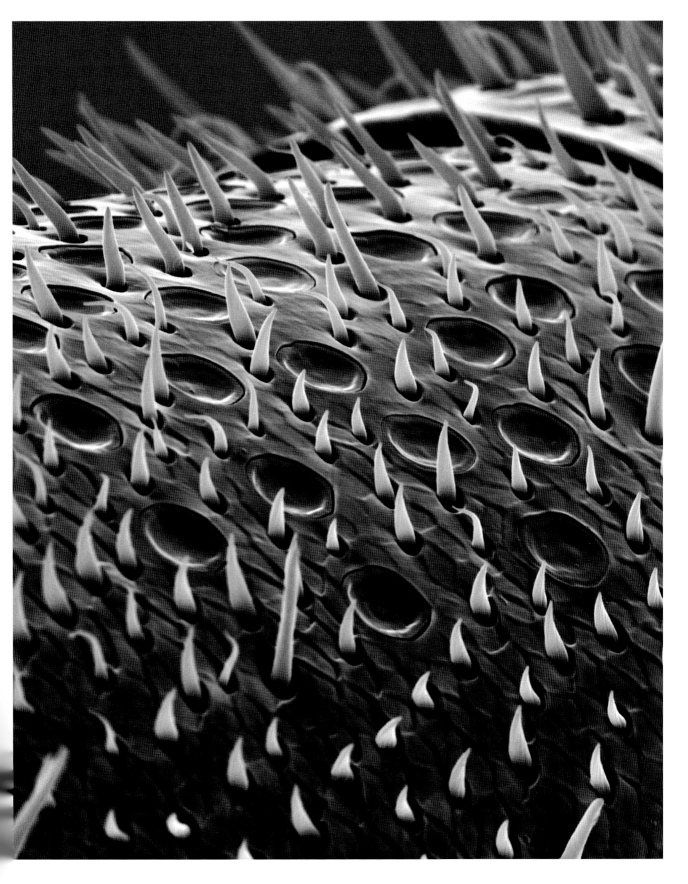

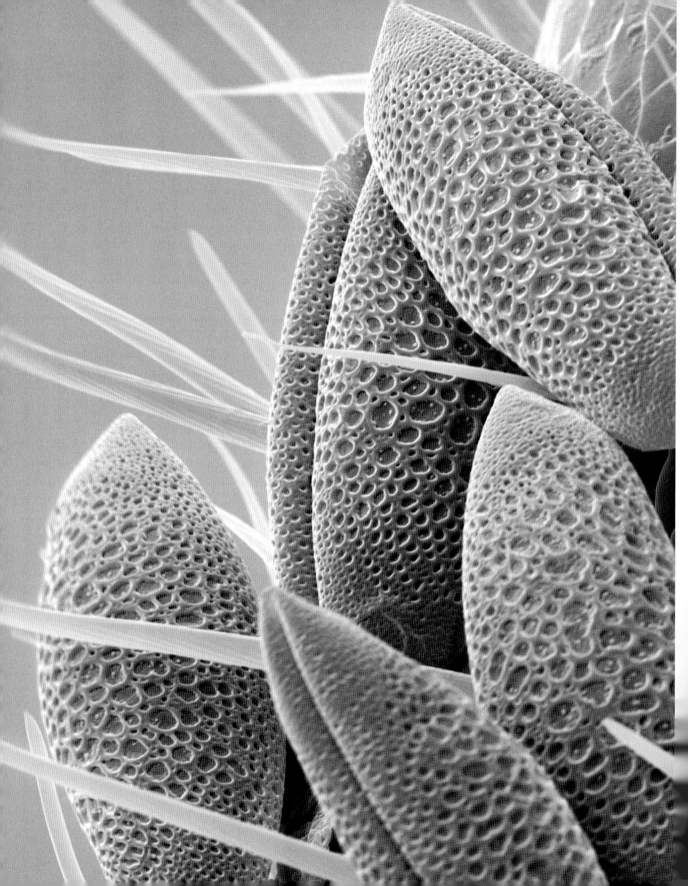

antenna 1100x

Pollen is inadverently collected by hair all
over the bee's body.

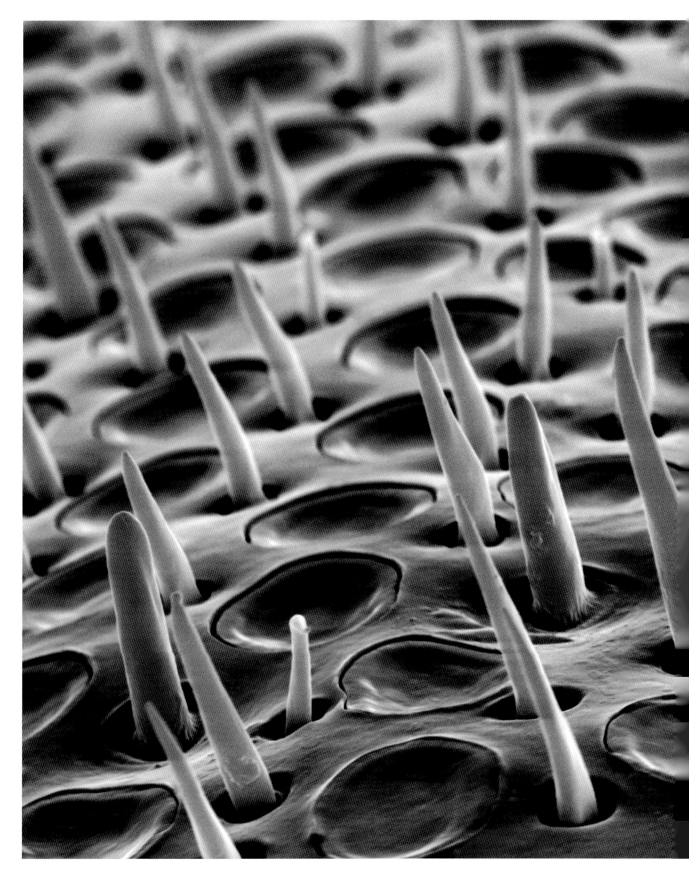

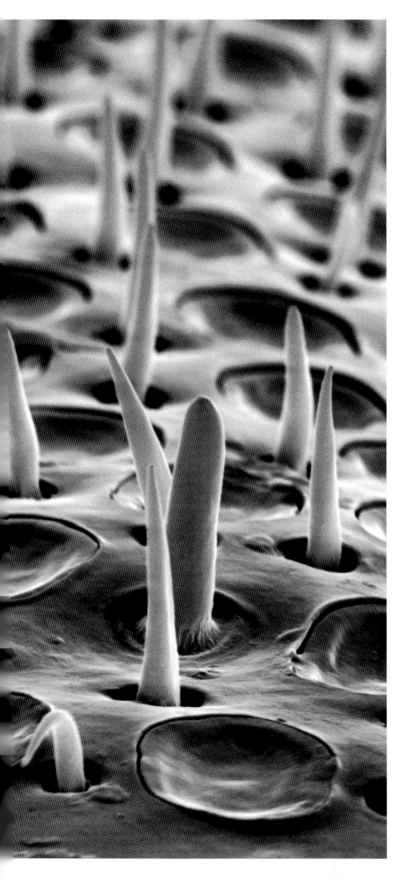

antenna 1700x

The sensory terrain of the flagellum

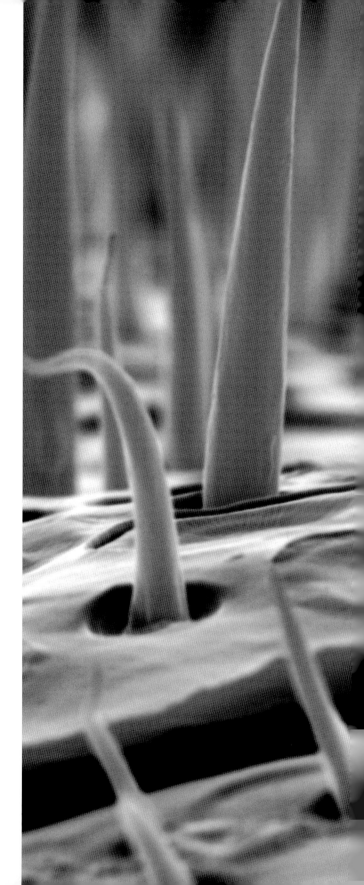

antenna 3300x

These are tactile sensory hairs on the
flagellum of the antenna.

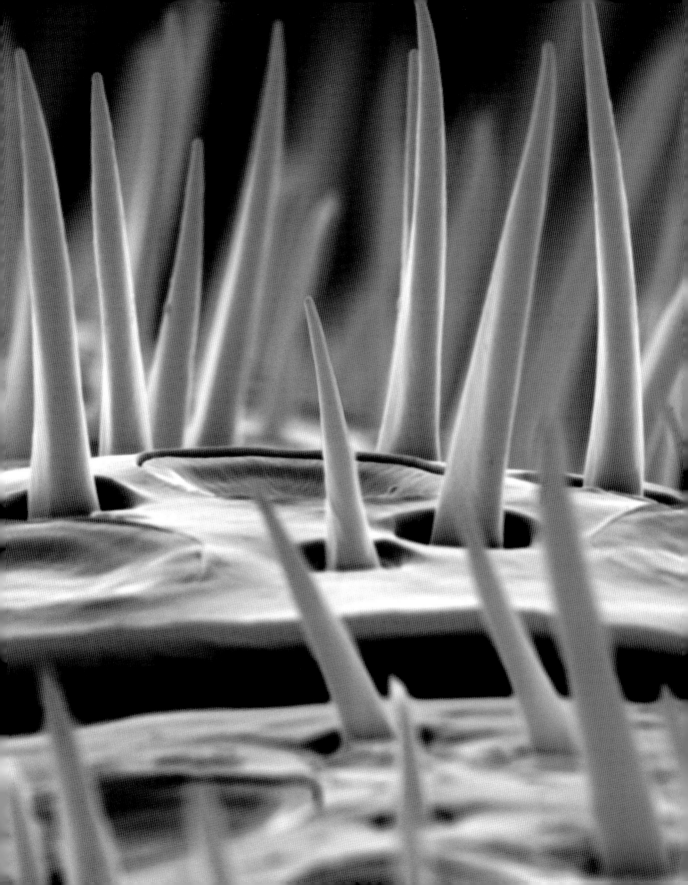

body

The body of the honeybee comprises the head, thorax, and abdomen. The antennae, eyes, proboscis, and mandibles are part of the head; four wings and six legs are attached to the thorax; the internal and reproductive organs, glands, wax plates, and sting are parts of the abdomen.

rear 10x

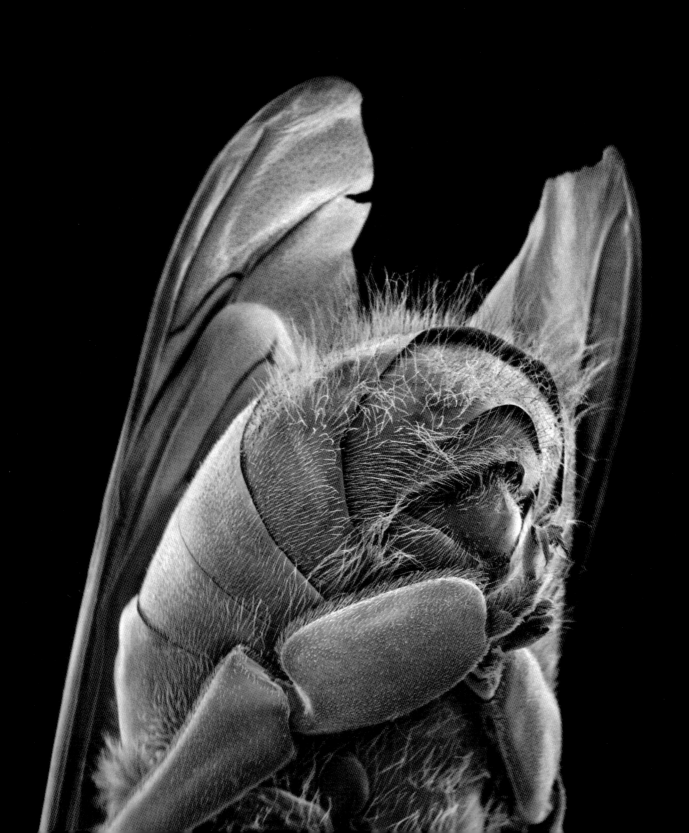

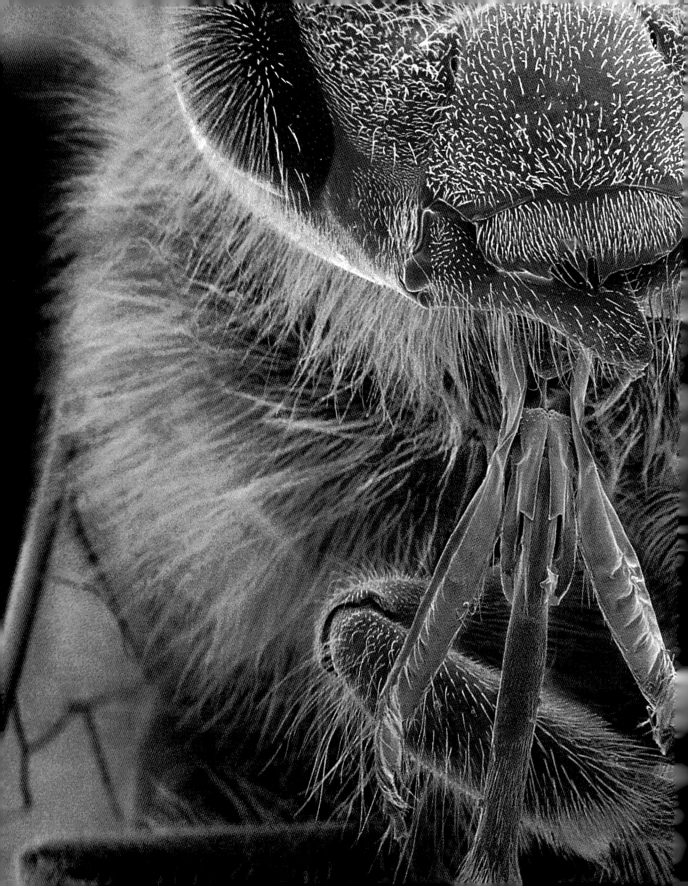

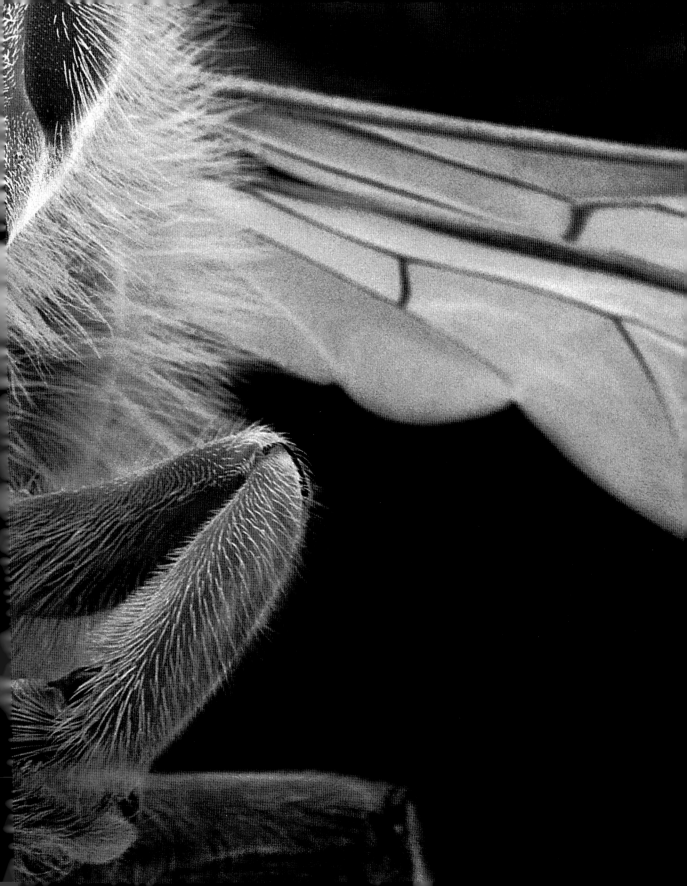

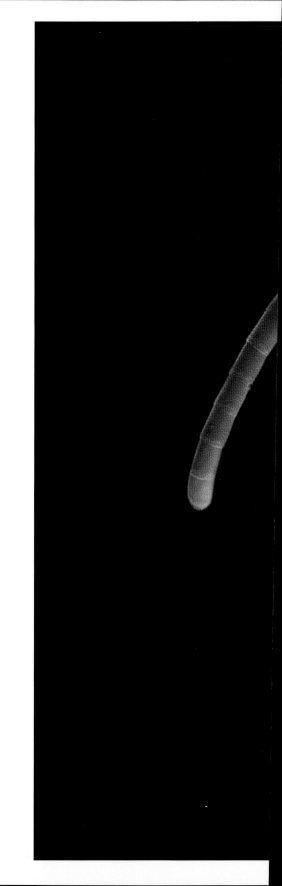

Beatrice 14x (previous)

Sabine 15x

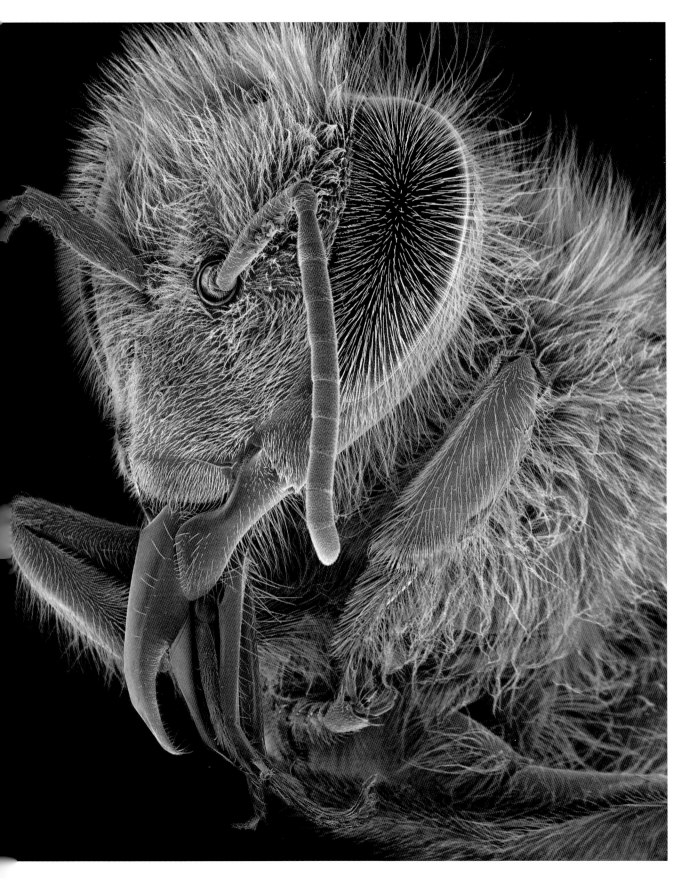

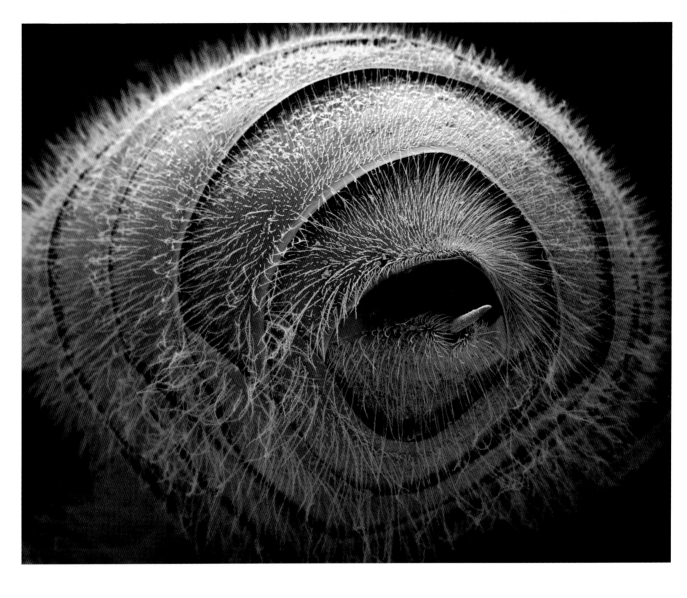

abdomen 23x (above)

Foreshortened view of the abdomen
with sting

abdomen 27x (opposite)

Overview of the tergal *sclerites,* plates on
the upper side of the abdomen

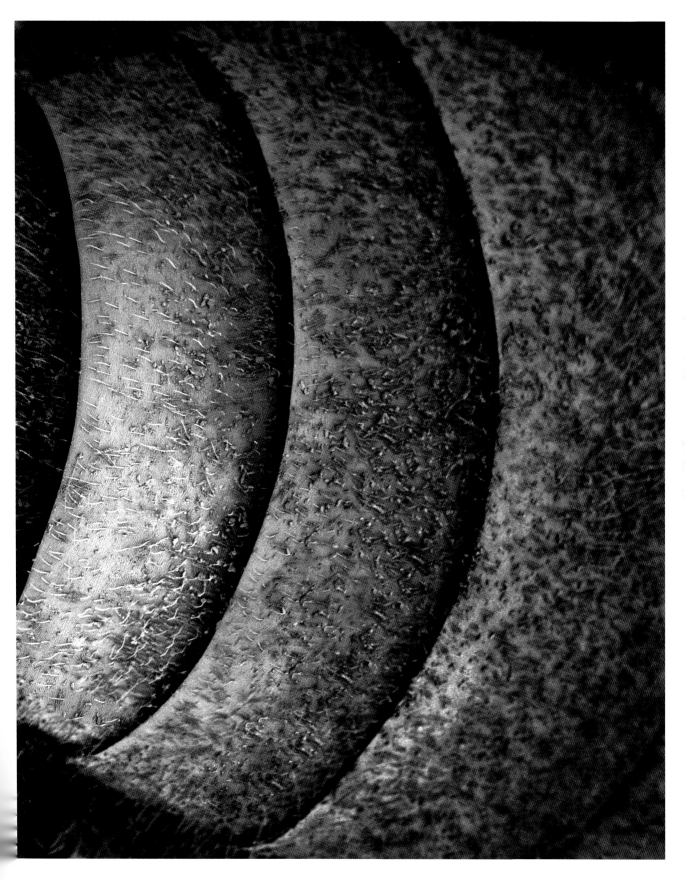

abdomen 30x

A side view of the interweaving edges of
the tergal and sternal sclerites, the upper and
lower abdominal plates

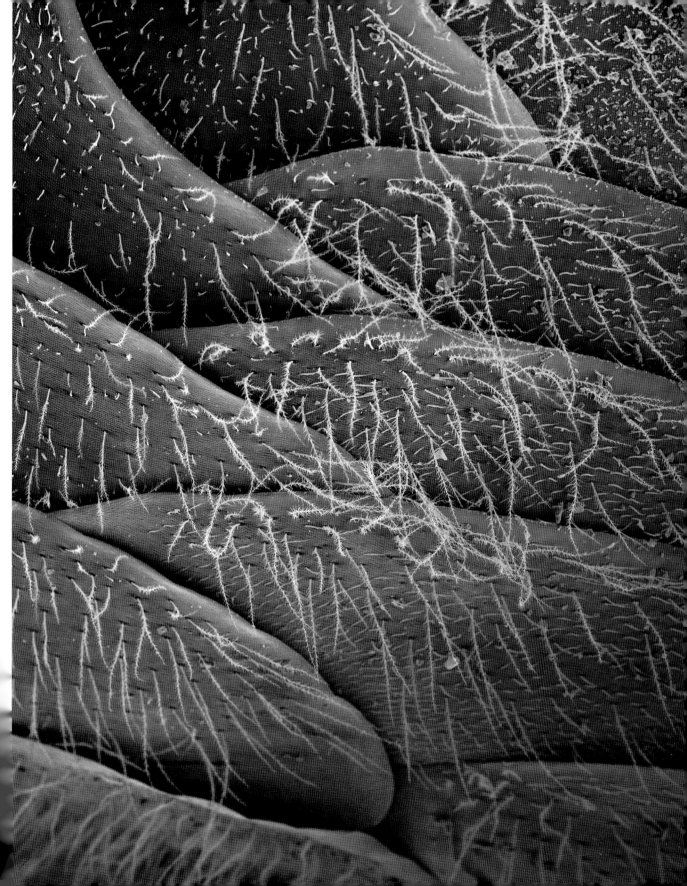

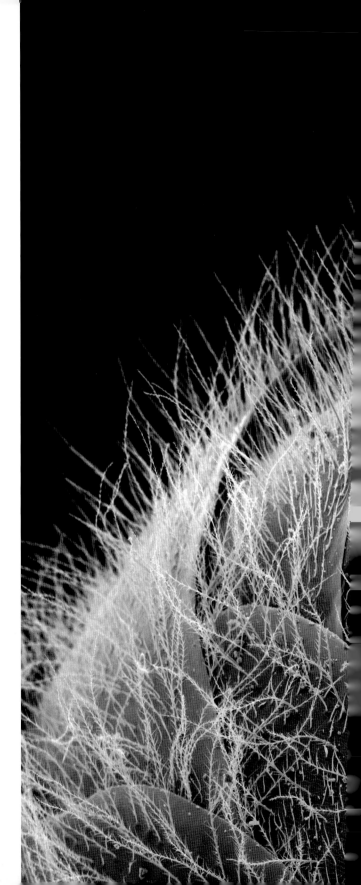

sting 37x

The sting is a modified *ovipositor* (the organ for laying eggs). A bee will only sting in self-defense or in defense of the hive. When threatened, she releases a *pheromone*, a chemical signal that alerts other bees, triggering a defense response.

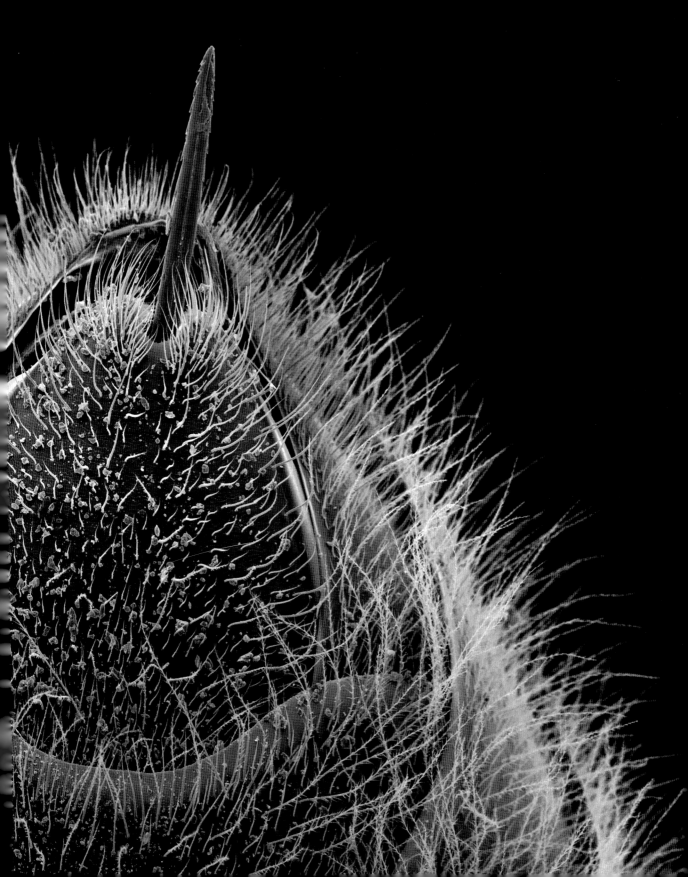

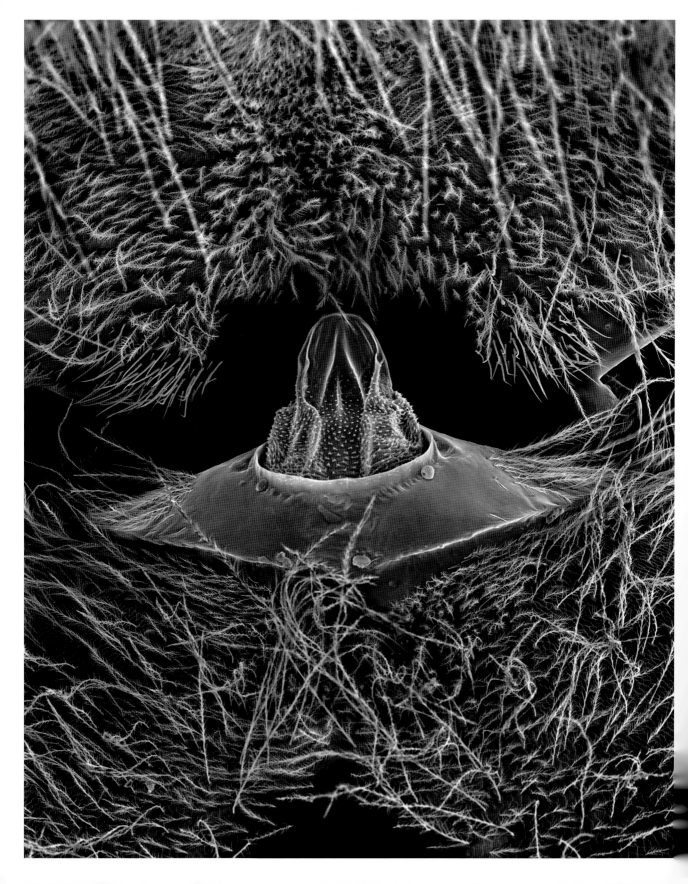

abdomen 70x

The abdomen is divided into the *propodeum* (first segment) and the *metasoma* (the remaining segments) at the *petiole* (a narrow constriction). This is a seldom-seen view of the end of the propodeum that is ordinarily hidden (it fits into the opening of the second segment). The petiole enables agile movement of the metasoma for laying eggs, mating, or stinging.

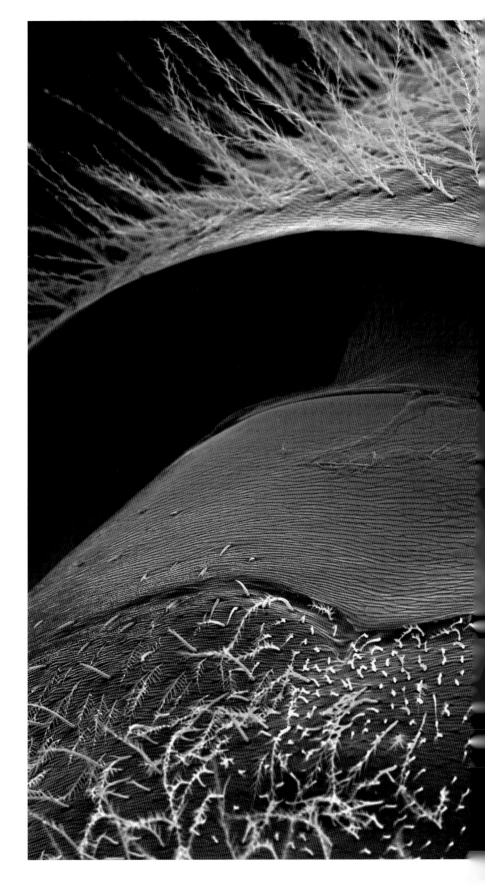

body 75x

One abdominal sclerite (plate)
overrides the next.

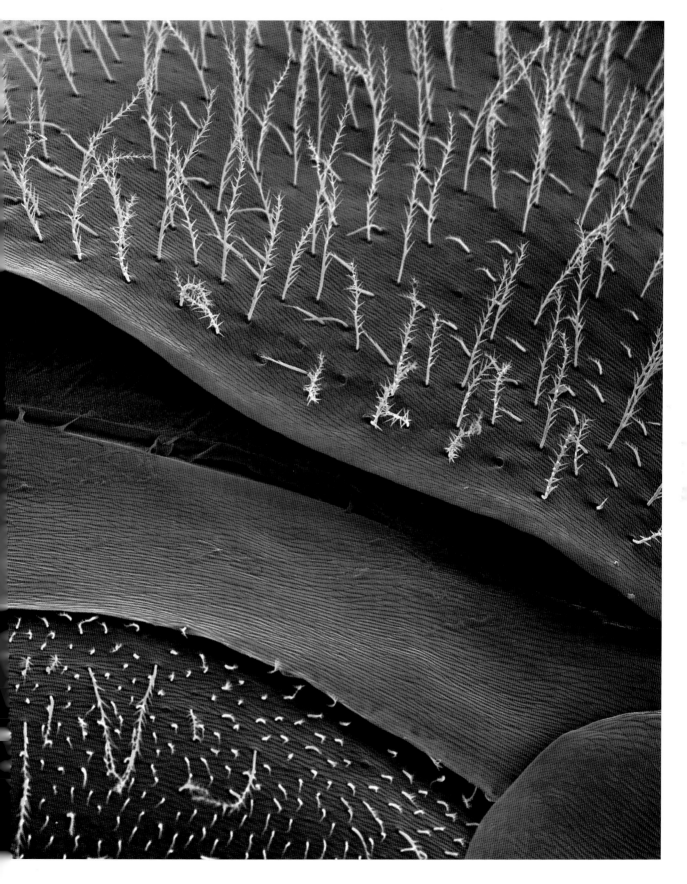

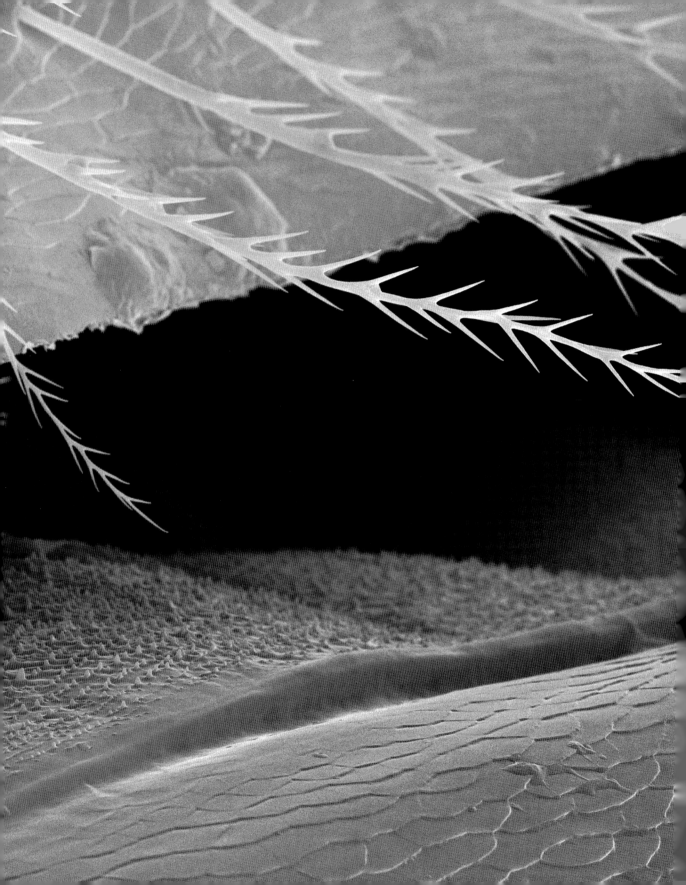

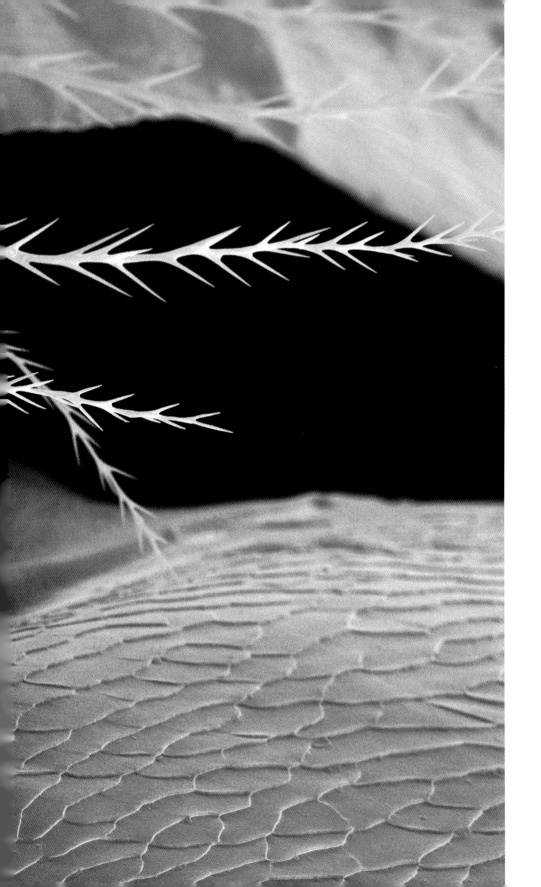

abdominal terrain 370x
(previous)

sting 650x (opposite)

When a bee stings a person, bear, skunk, or
other mammal, the barbs of the sting become
anchored in the flesh. As she tries to free
herself, the last segment of her abdomen is
ripped out and she dies.

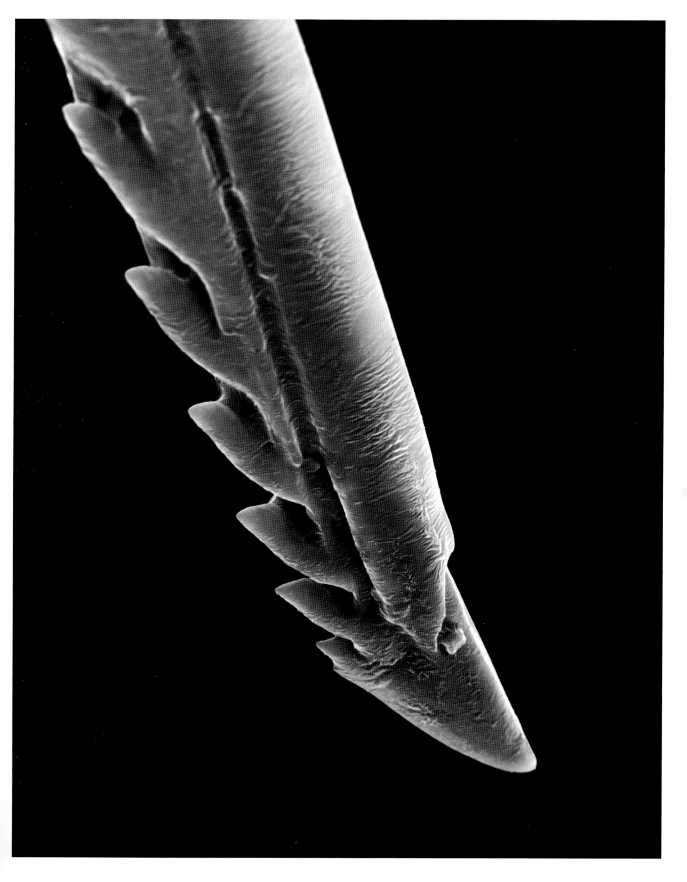

eye

The honeybee has two large, hairy, compound eyes each made
up of thousands of hexagonal, faceted lenses called *ommatidia* that
detect movement and are sensitive to both ultraviolet and polarized
light; the latter allows the honeybee to orient herself to the
position of the sun throughout the day. There are also three
single-lens *ocelli* (simple eyes) on the head that monitor light
intensity. These ocelli are necessary for navigating around flowers
and knowing when to return to the hive as dusk approaches.

compound and simple eyes
of drone 23x

A drone's compound eyes are larger than a
worker's or a queen's, with up to eight thousand
lenses each and an almost 360 degree range of
vision—the better to pursue the queen during
his mating flight.

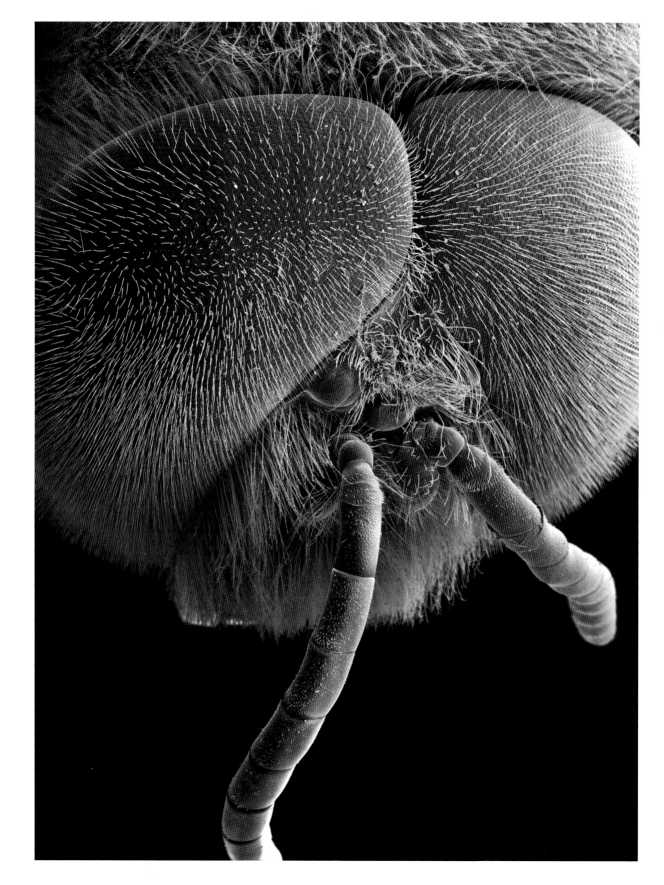

hairy eye 70x

Hairy eyes are only found among a few of
the twenty thousand species of bees.

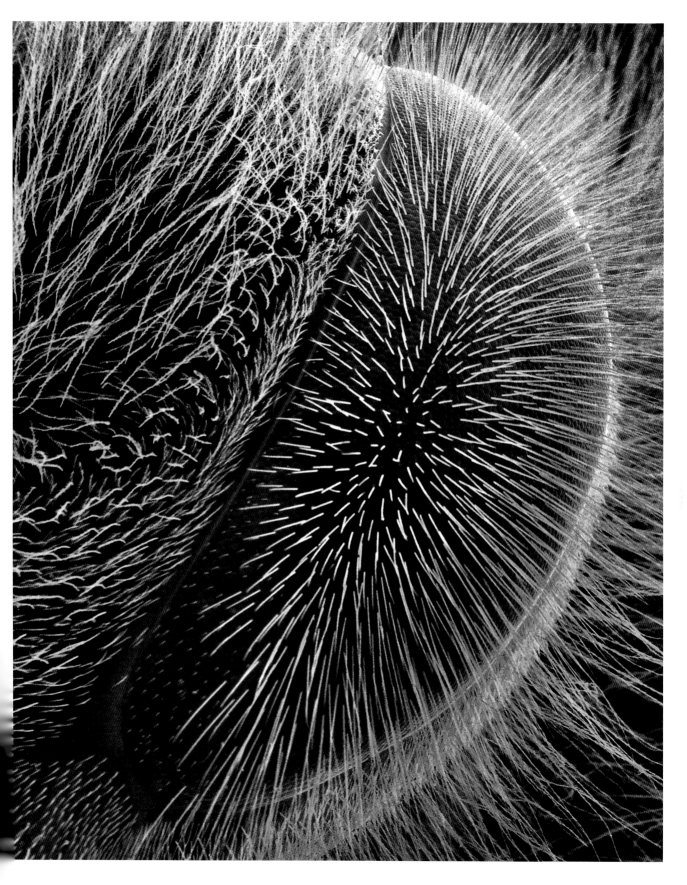

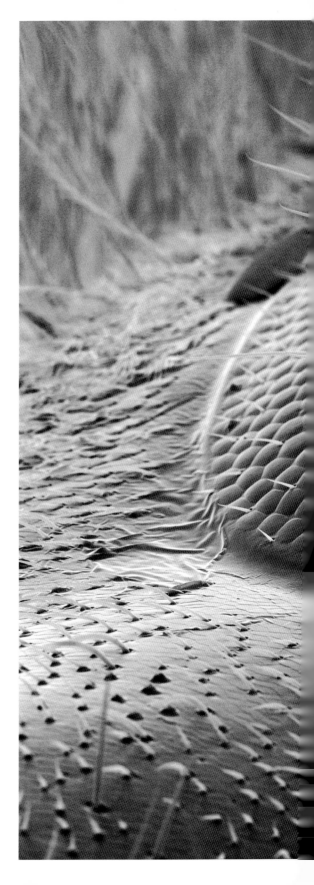

elliptical dome of
bee eye 190x

Honeybees perceive the range of the color
spectrum from yellow to ultraviolet light;
red is perceived as black. Ultraviolet light
reveals patterns, contrasts, and markings
in flowers that are imperceptible to humans,
but visible and attractive to the honeybee,
informing her where to land and where to
find the nectar and pollen.

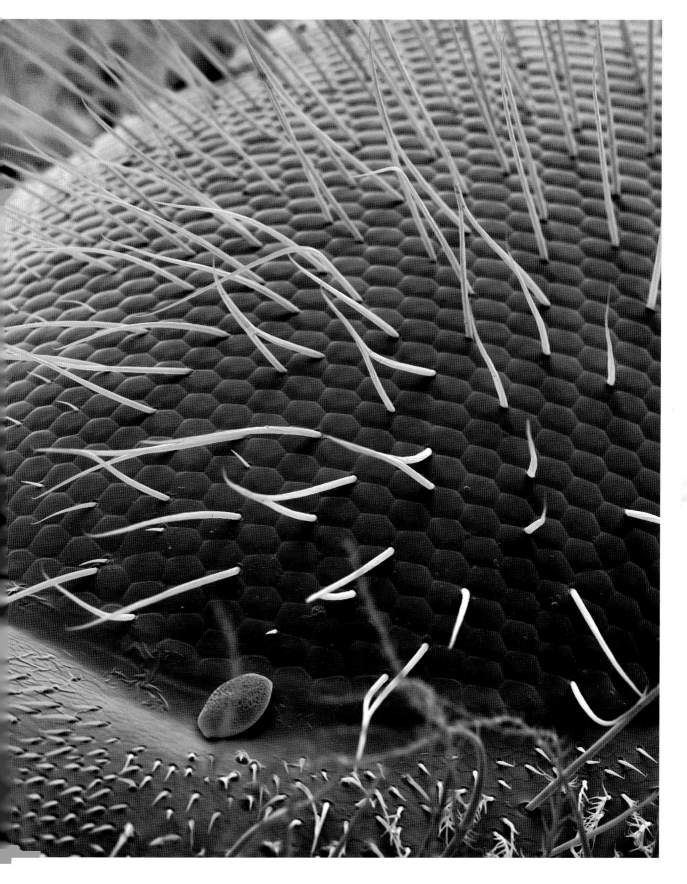

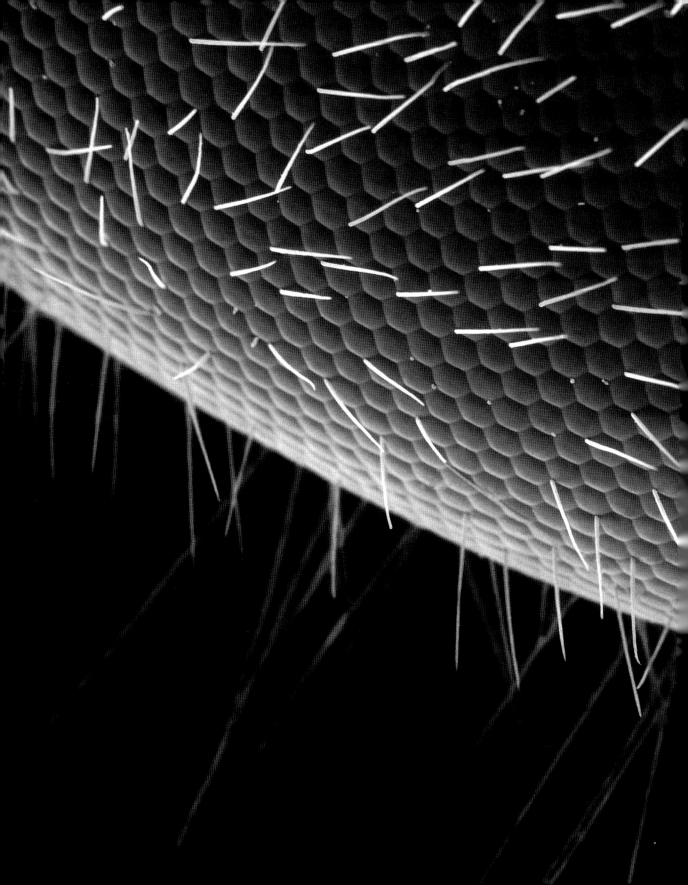

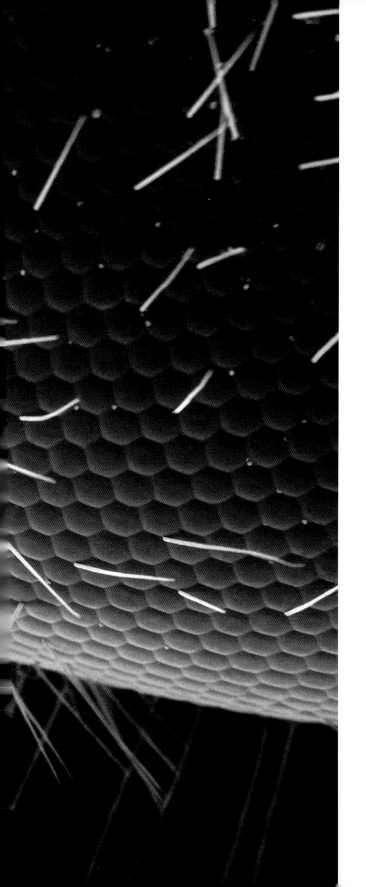

eye 200x

Each worker's compound eye comprises
about 6,900 hexagonal, faceted lenses, and
each lens captures light from its own angle.
Combining visual information from each
tiny eye, forms are perceived as a mosaic of
dots rather than with fine detail. Bee vision
is better suited to perceiving light and
motion than form.

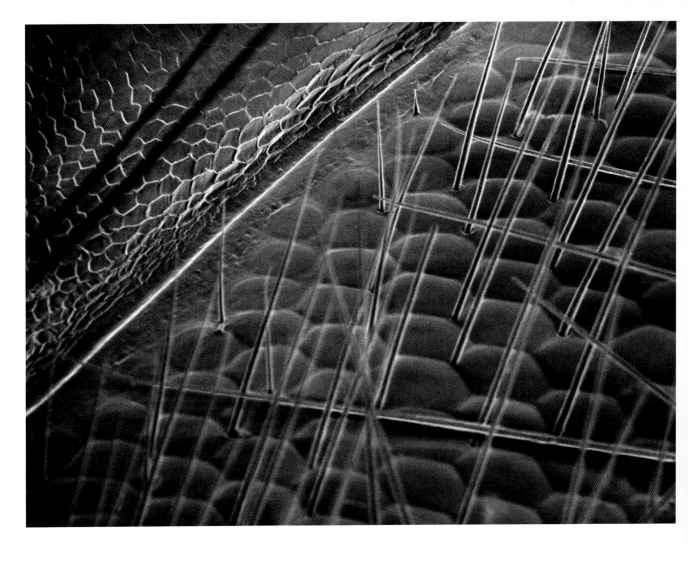

eye 370x

Edge of compound eye with hair

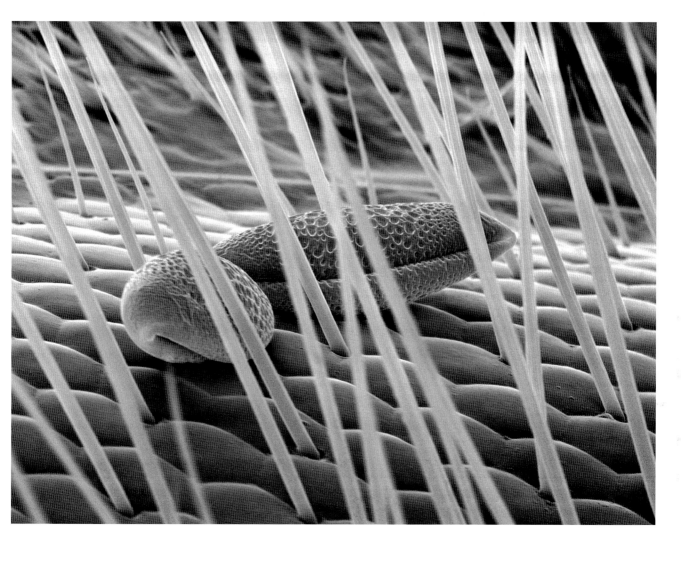

eye pollen 800x

The hairs on bees' eyes collect pollen as well.

leg

The bee has three pairs of segmented legs attached to the thorax,
whose coordinated and integrated functions are applied to
collecting, cleaning, prying, pushing, brushing, scraping, raking,
pressing, carrying, building, and walking. To illustrate:
Using her forelegs and mandibles to loosen pollen from a flower,
a foraging bee is dusted in pollen. She cleans her head and
mouthparts with foreleg brushes, her forelegs with middle leg
brushes, and then, grasping a middle leg with both hind legs, she
draws it forward, transferring the pollen through to her hind
leg brushes. She rubs her hind legs together scraping pollen from
brushes on one leg with the *rastellum* (rake) of the other, on to the
auricle (ledge) of the pollen press. With a pumping action she
pushes the pollen into the *corbicula* (pollen basket), and through
this repeated motion it collects into a pellet. This is all
done while hovering in the air.

pollen basket 17x

A full corbicula on the outer, slightly concave
surface of the hind tibia. Curved, fringing hairs
hold the pollen pellet in place during flight.
The corbicula is also used for collecting and
transferring propolis.

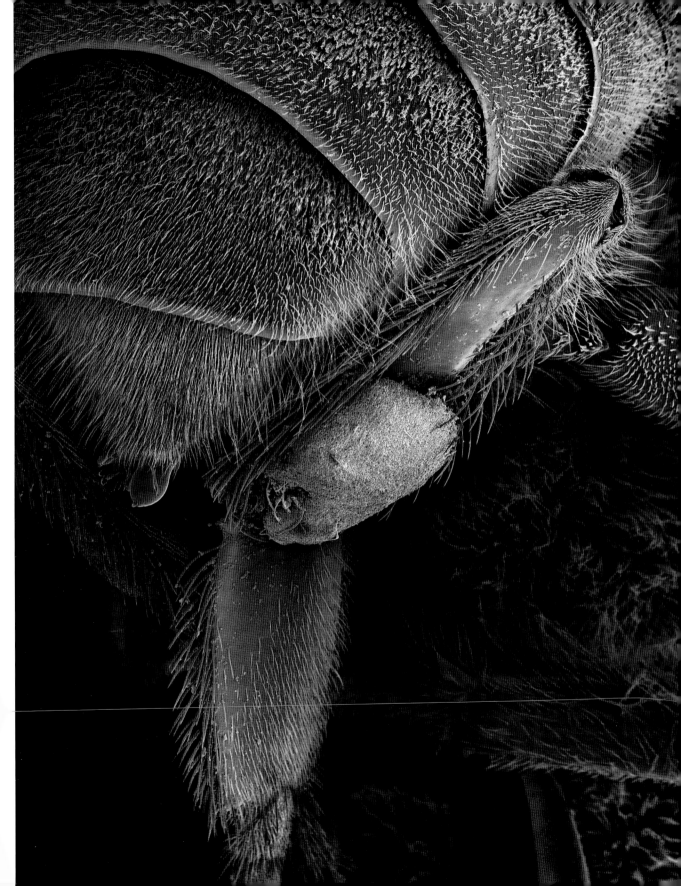

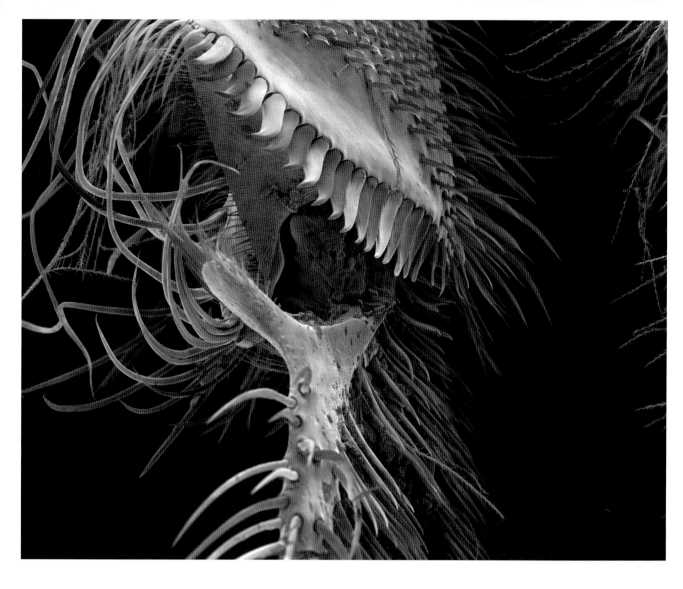

pollen press 85x (above)

View of the rastellum and the auricle where
the tibia meets the *basitarsus* on the inner side
of the hind leg

pollen press hind leg 130x
(opposite)

The joint between the tibia and the basitarsus
on the outer side of the hind leg, showing the
long, curved hair of the pollen basket, and
the auricle of the pollen press

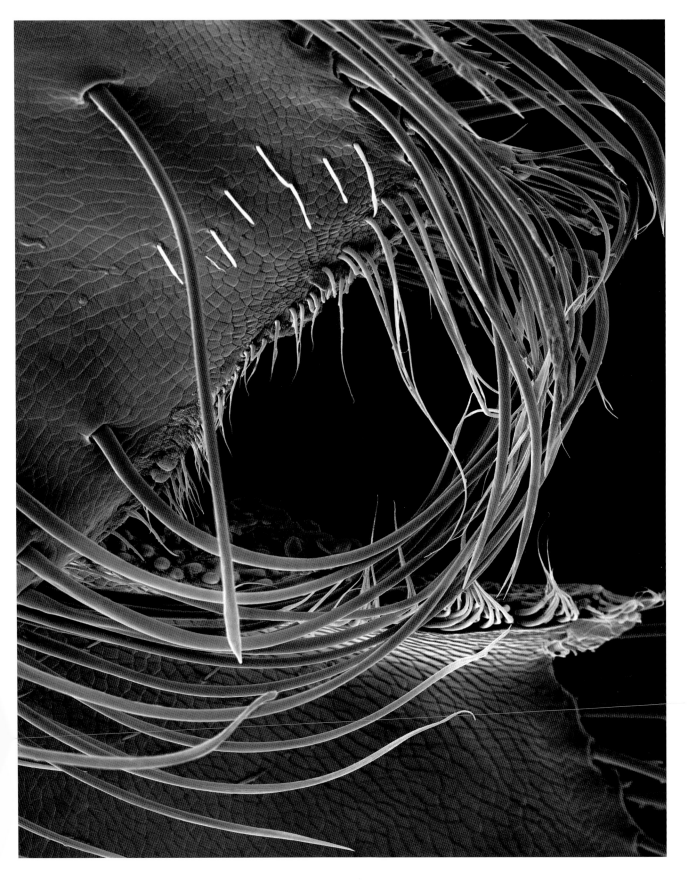

the bee's knee 330x

The joint between the bee's femur and tibia

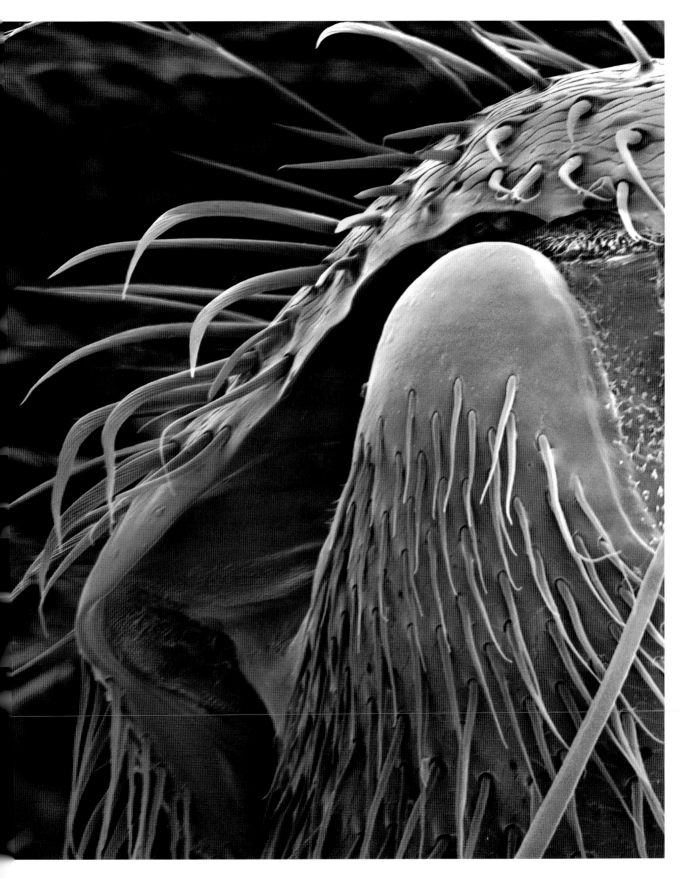

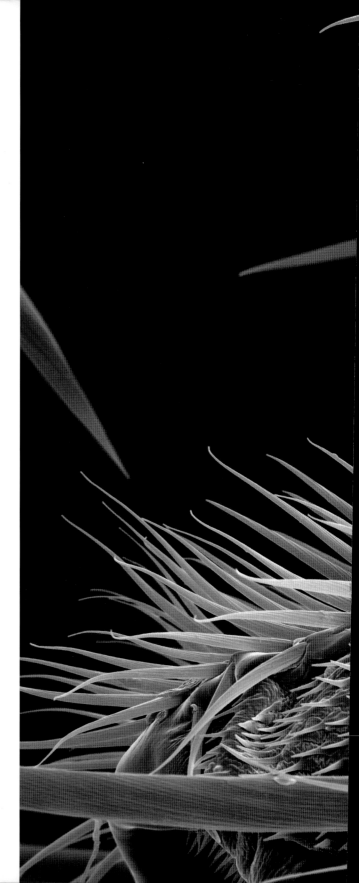

tarsus 450x

The area between two *tarsomeres*. A tarsomere
is one of the five divisions of the *tarsus*, the
segment of the leg between the tibia and
the *pretarsus*.

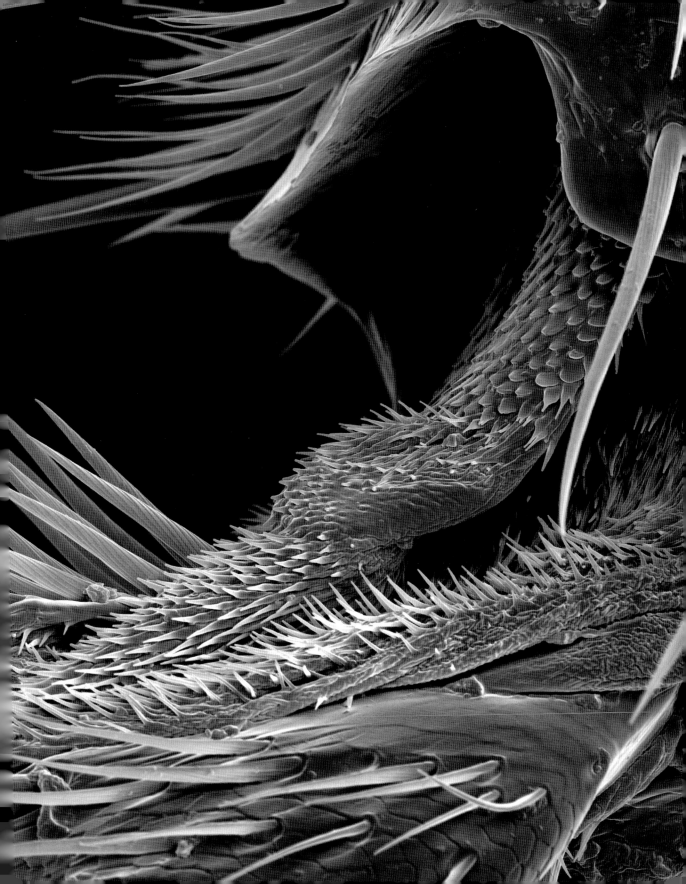

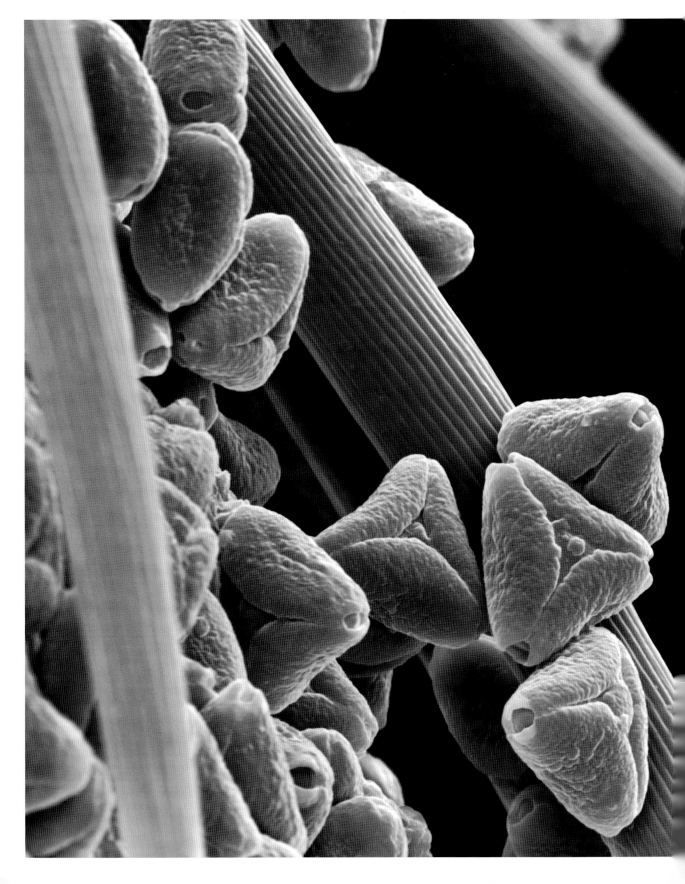

leg pollen 1100x

Pollen lodged in the pollen basket, anchored
by the bee's hairs

proboscis

The mouthparts of the bee include the *proboscis* and the mandibles.
The proboscis is a complex apparatus comprising many parts,
including the *maxillae*, *labia*, and *glossa* (tongue) that function
together to create a strawlike, airtight chamber for drawing
up nectar, honey, and water. It also works in reverse, allowing
the bee to transfer food to others. When a honeybee ingests nectar
from a flower, it travels through the alimentary track to
the abdomen into a sac called the *crop* (honey stomach). Returning
to the hive, she transfers stored nectar to other workers who
digest and then regurgitate it into empty honeycomb cells. Once it
thickens into honey, each cell is capped and sealed with beeswax

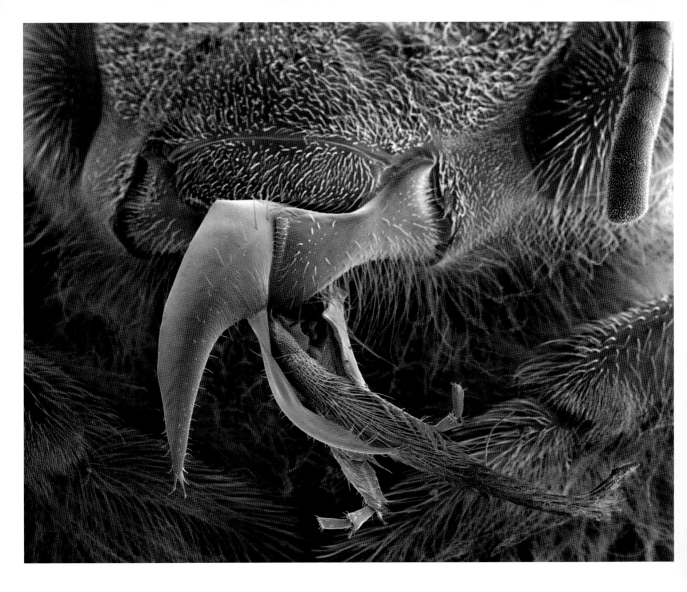

proboscis and mandibles 27x

A view of the maxilla, labial *palpus*, glossa, and
mandibles. Mandibles are the bee's jaws. They open
and shut to bite, grasp, or cut, swinging in and
out on hinges. They hold the base of the proboscis
while feeding, bite pollen, work wax in comb
building, work propolis, feed larvae, release flower
pollen, pack pollen, drag debris, and can also be
used for defense.

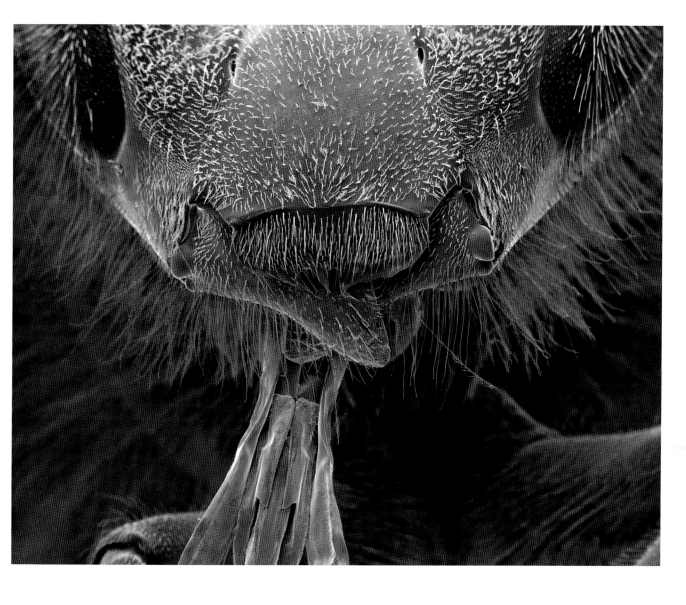

proboscis 30x

A view of the clypeus above the labrum, folded mandibles, and the base of the proboscis. When not in use, the glossa retracts and the proboscis folds up on hinges behind the head.

proboscis 100x

A closer view of the glossa, flanked by the *galea*
(the lower, tapered, bladelike part of the maxilla).
In addition to being a feeding organ, the proboscis
is also used to lick queen pheromones, the chemical
signals the queen produces that regulate order
and organization within a colony. It is a form
of communication, inducing workers to attend her
and drones to mate with her.

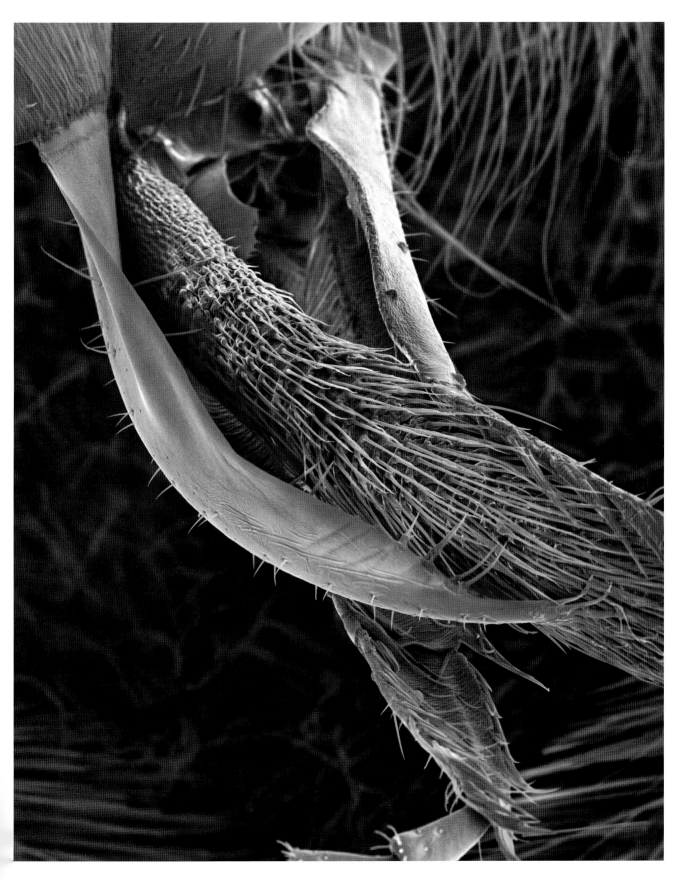

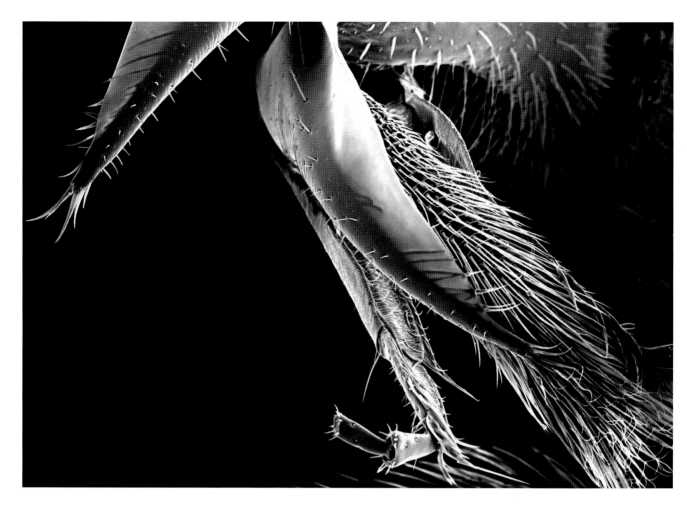

proboscis 100x

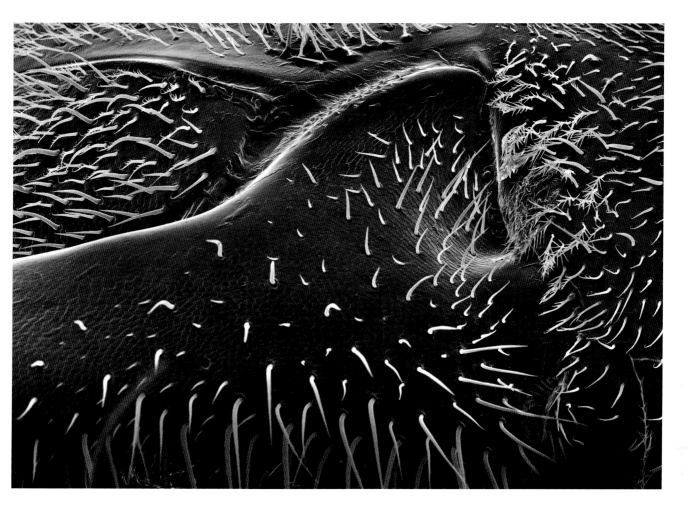

mandible 150x

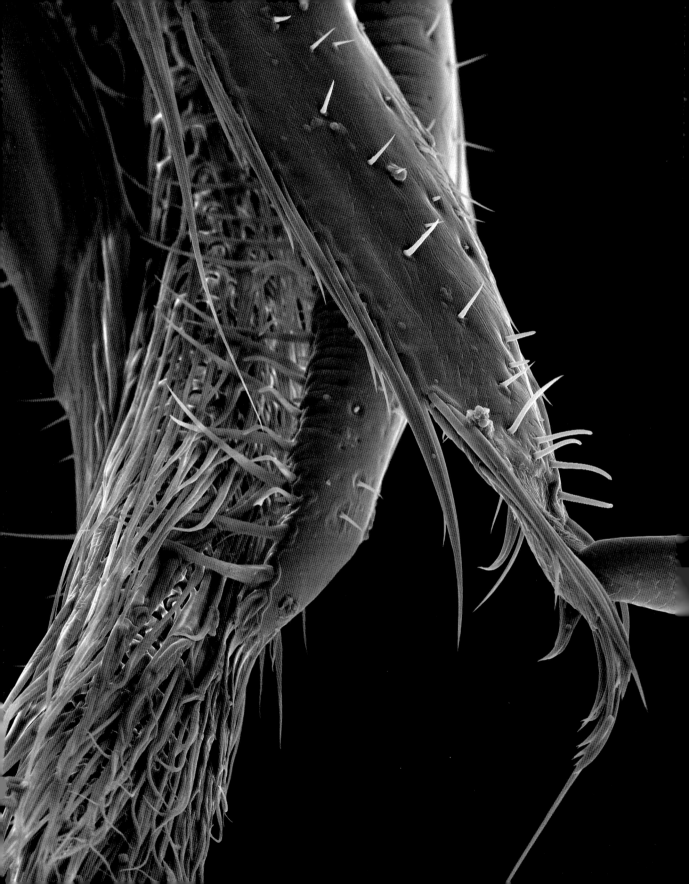

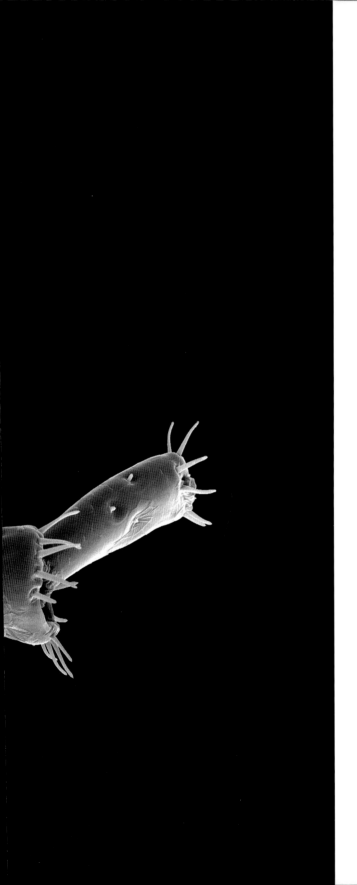

proboscis 150x

View of the labial palps and the glossa,
partially grasped by the galea

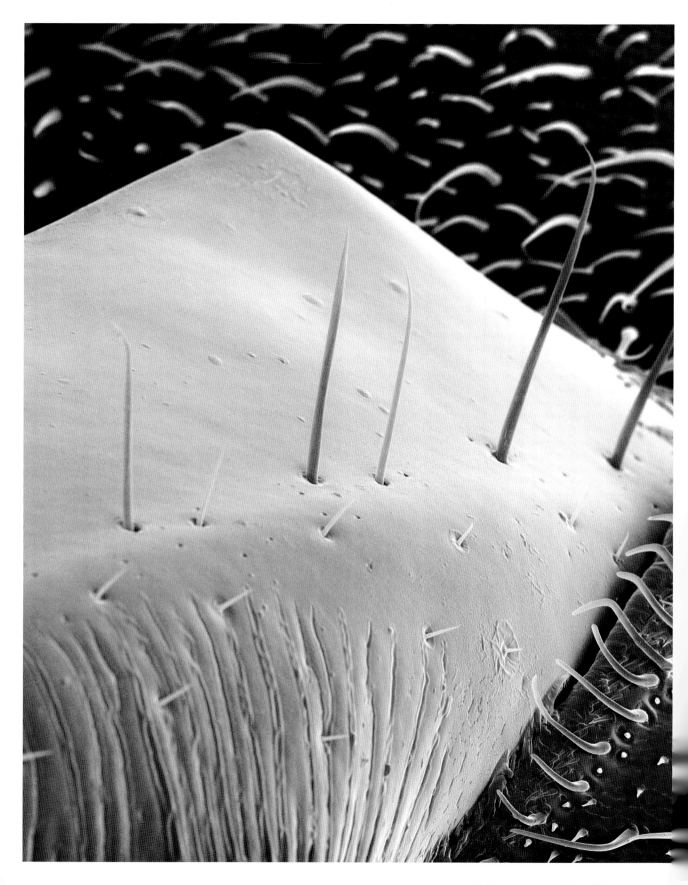

proboscis 250x

The edge of the mandible, on the right,
supporting the maxilla at left, and the
clypeus behind

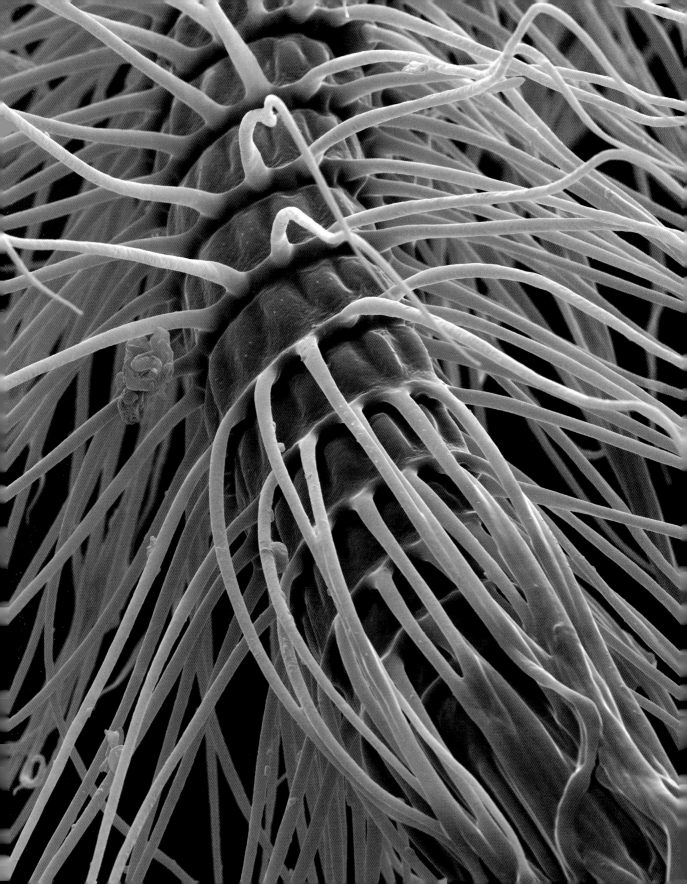

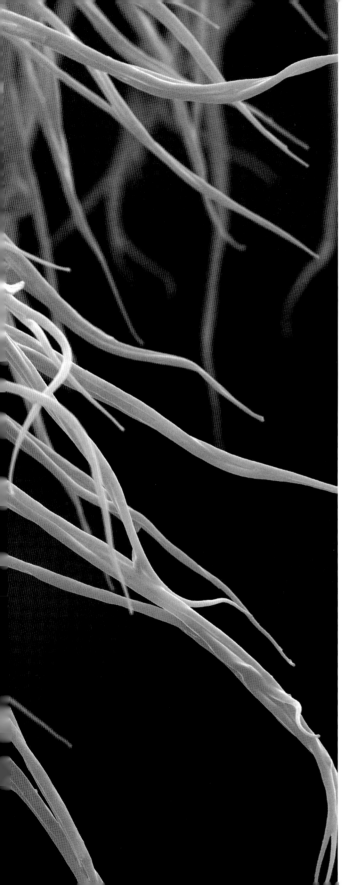

glossa 430x

proboscis 600x

Nectar, water, and honey are lapped up
and first absorbed by the *flabellum*, the flexible,
spoonlike tip of the tongue (glossa).

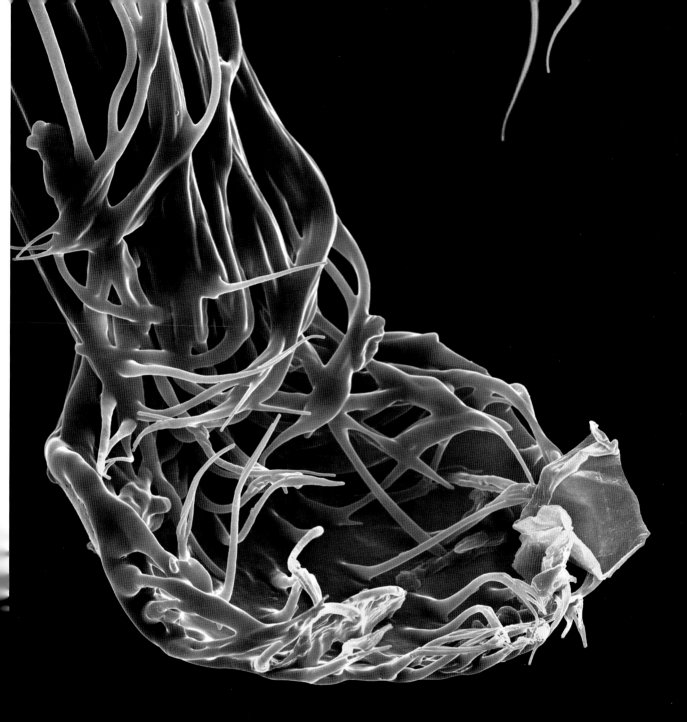

wing

The bee has two pairs of wings stemming from the thorax.
Each set is composed of a large forewing above a smaller hind wing.
A honeybee beats its wings up to 230 times a second, creating warmth
in the hive, in turn, evaporating water from the nectar in the
honeycomb, thickening it into honey. This rapid fanning of the
wings also produces their buzz.

drone's wing 10x

The drone's singular purpose within the colony
is to mate with the queen and, once accomplished,
he dies. Because mating occurs in-flight,
powerful wings are necessary to pursue the
queen, even if that means flying backward.

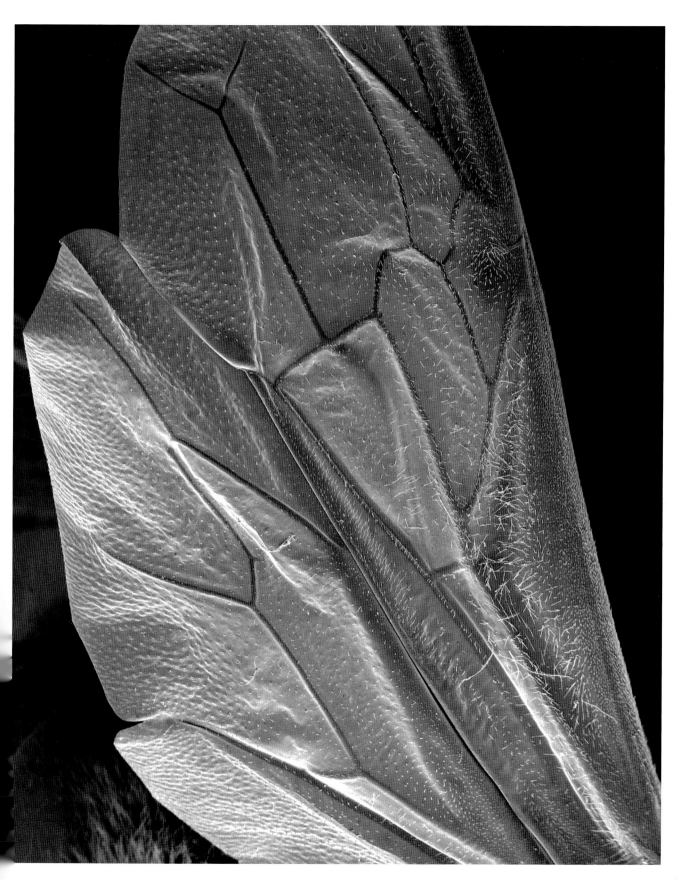

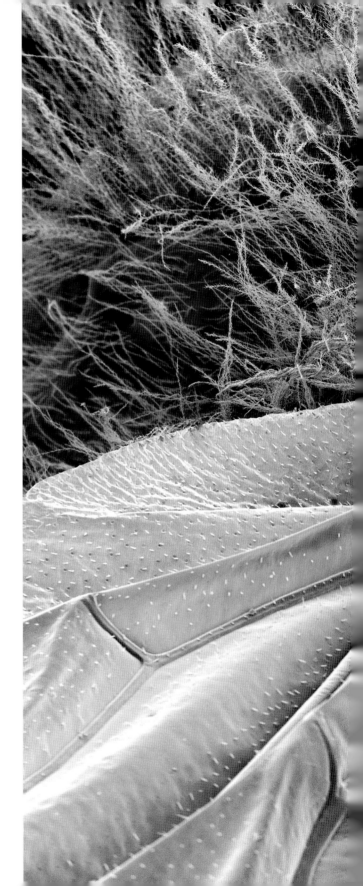

wing 30x

A long view of the base of the wing joints on the thorax. To fly, bees not only flap their wings up and down, but rotate and flip them as well.

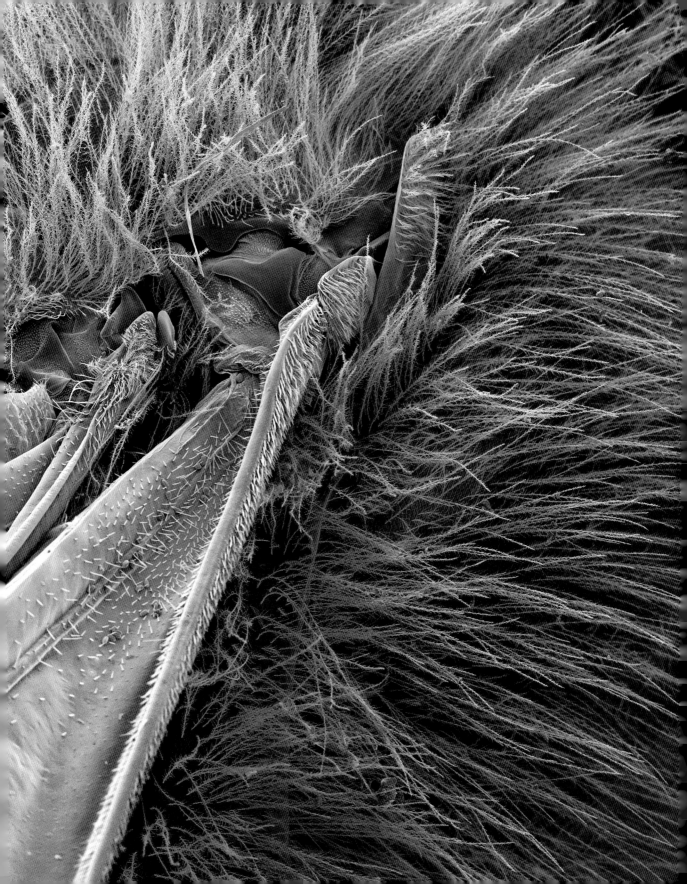

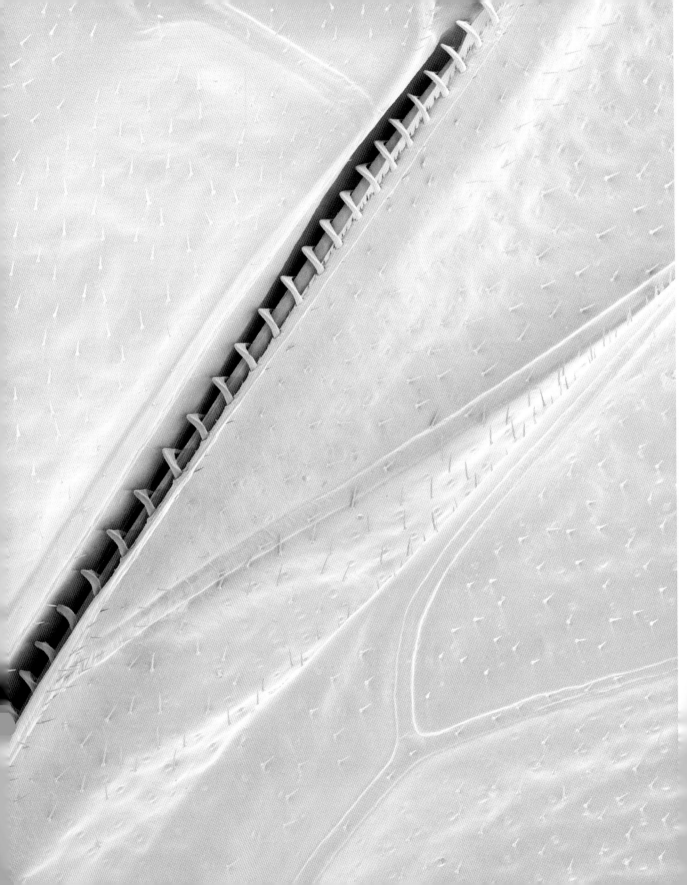

wing hooks 86x

The top edge of the hind wing has hooks called *hamuli* which catch on a fold at the bottom edge of the forewing; this interaction allows the two wings to function as one during flight. At rest the hamuli slip out, and the wings disconnect, each folding separately over the back.

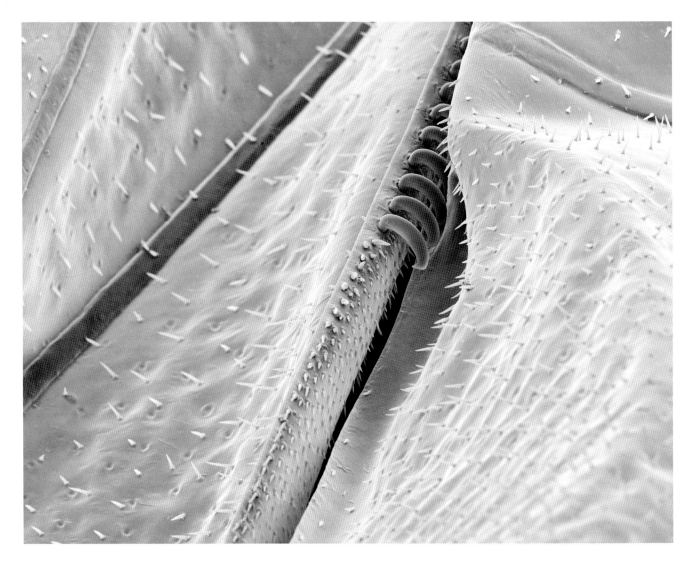

wing seam 160x

The wings hinged together

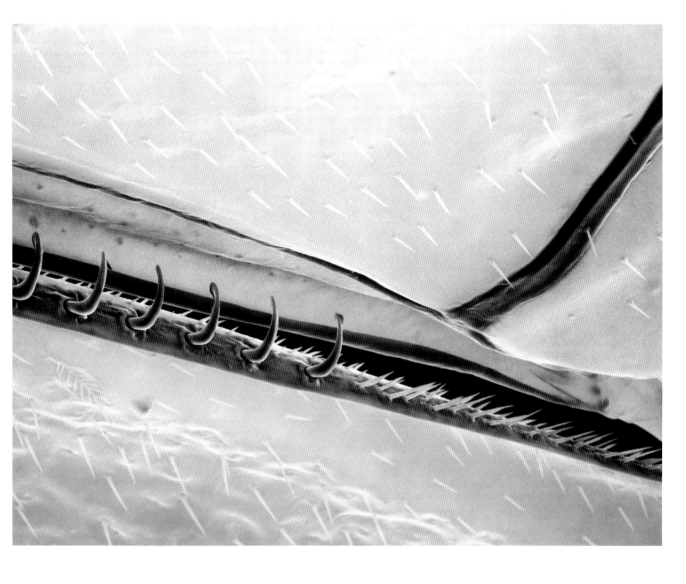

wing 170x

Another view of the hamuli attaching
to the wing fold

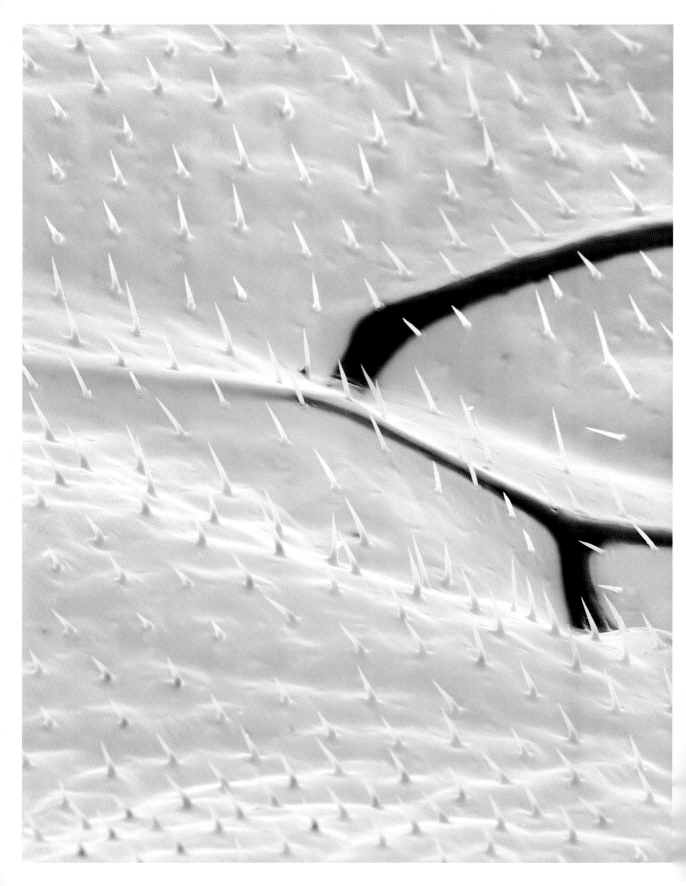

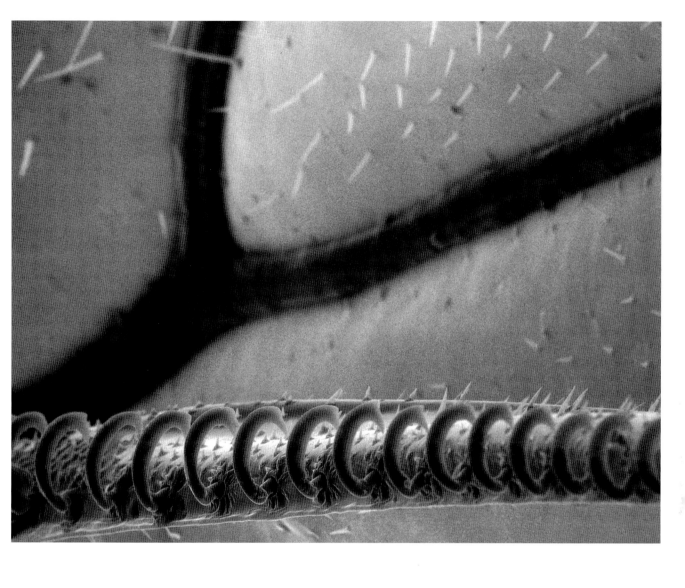

wing 170x (opposite)

Surface of wing with hair and veins

wing 180x (above)

The wing hinge

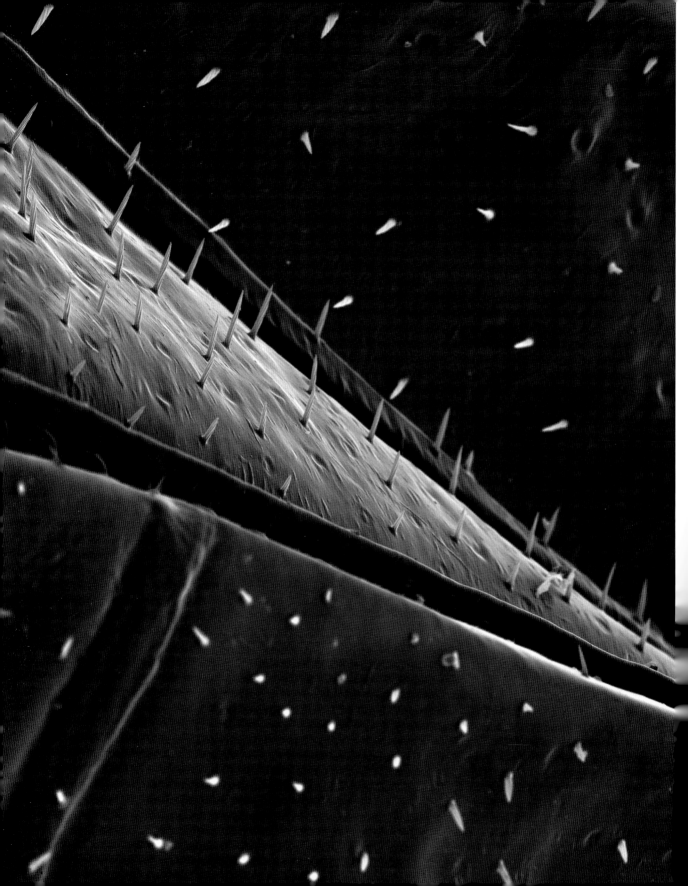

wing 270x

A study of the geometric forms of
the wing's regions

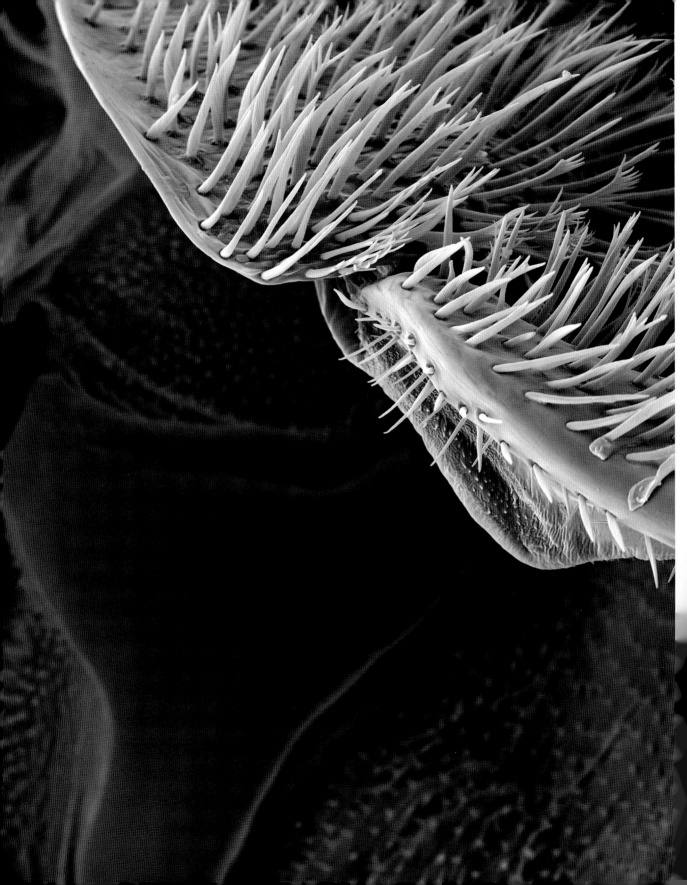

wing base 300x (opposite)

Close-up of the base of the wing joint at
higher magnification (see page 102)

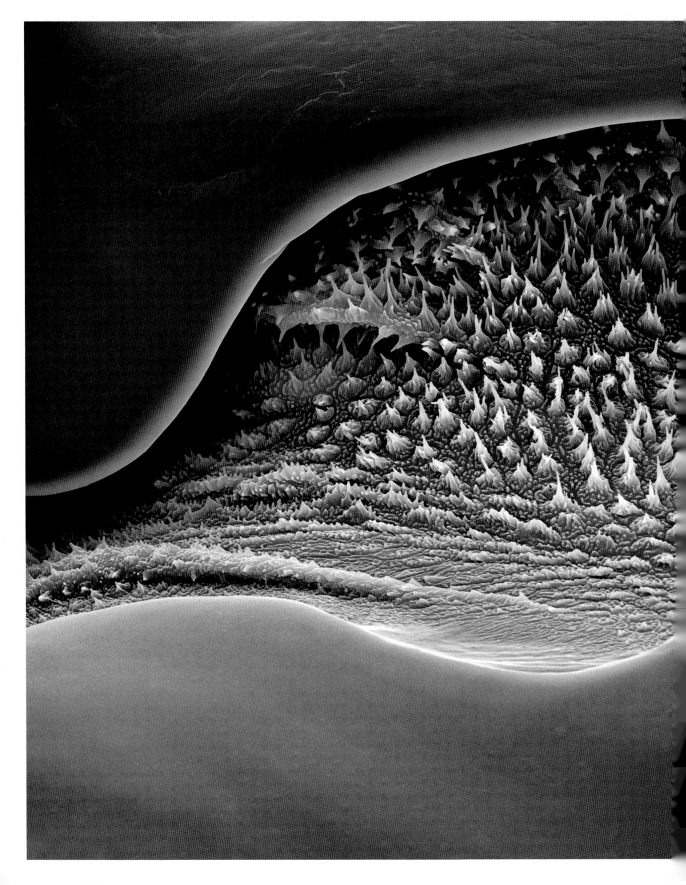

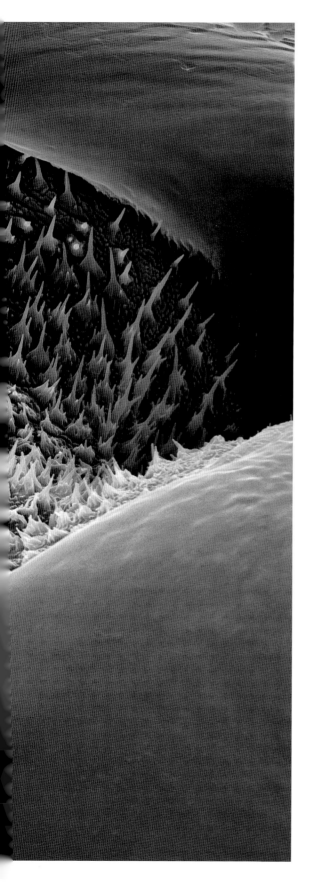

wing base 550x

Close-up of the wing base (see page 102).
The inner slope is a membrane composed of
cuticular spine clusters.

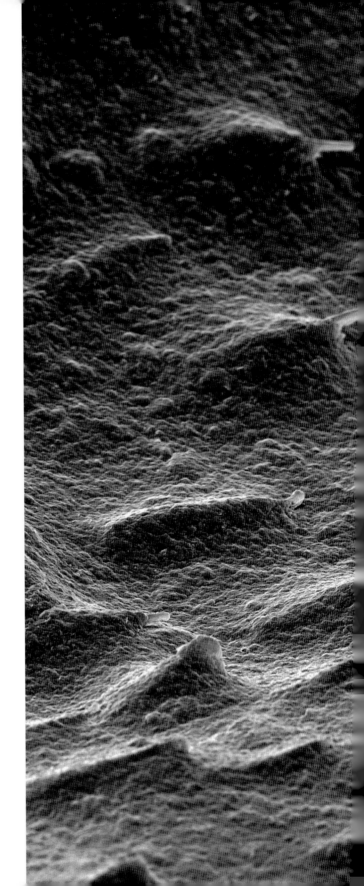

wing surface 600x

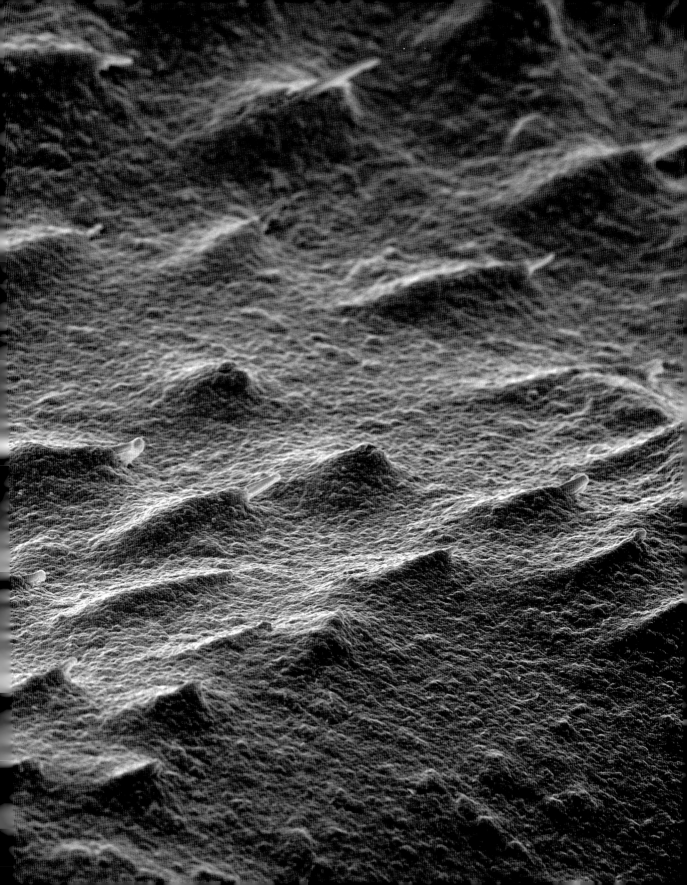

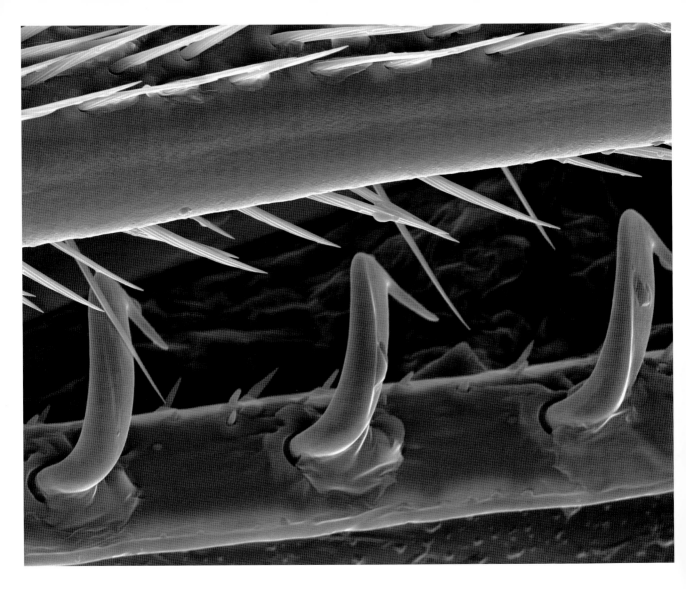

detail of wing hooks 600x

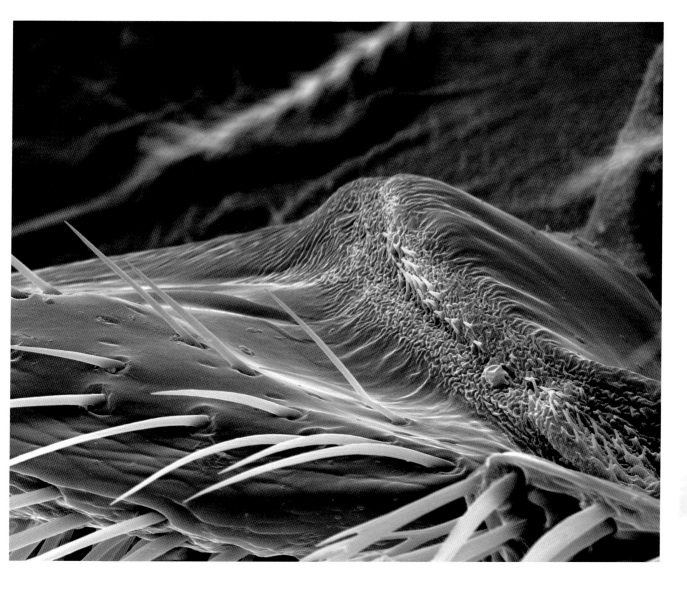

wing base 650x

drone's wing 650x

Detail of the strong, membranous structure
at the base of a drone's wing

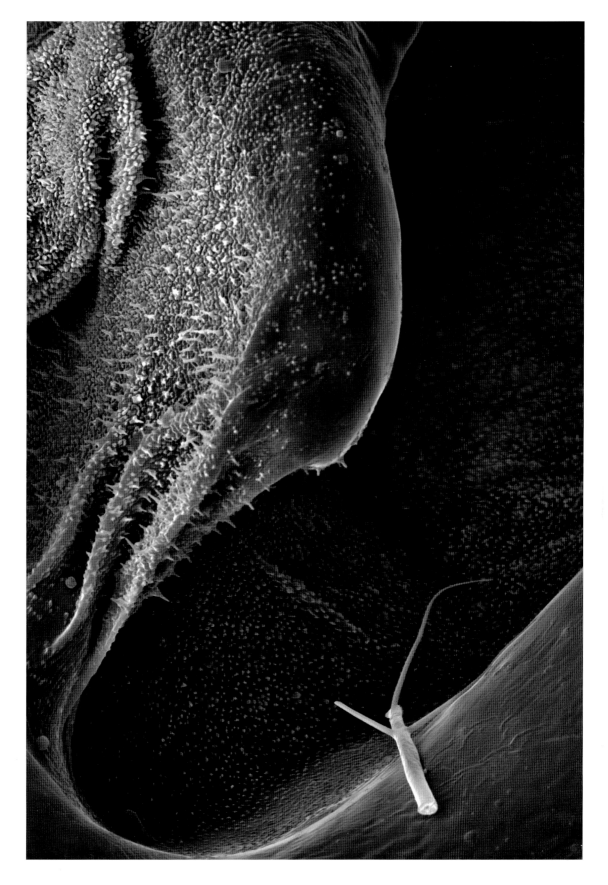

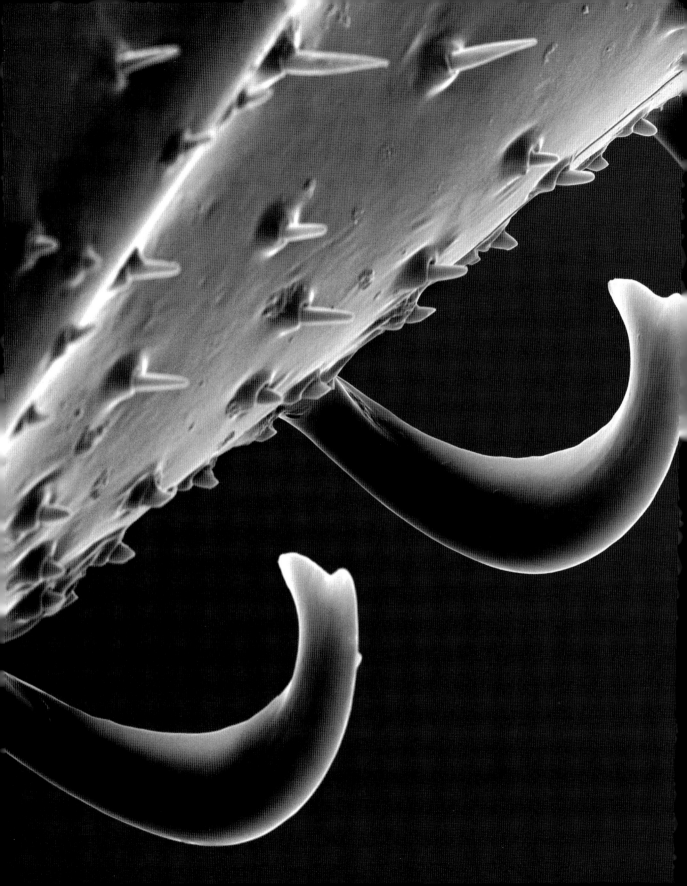

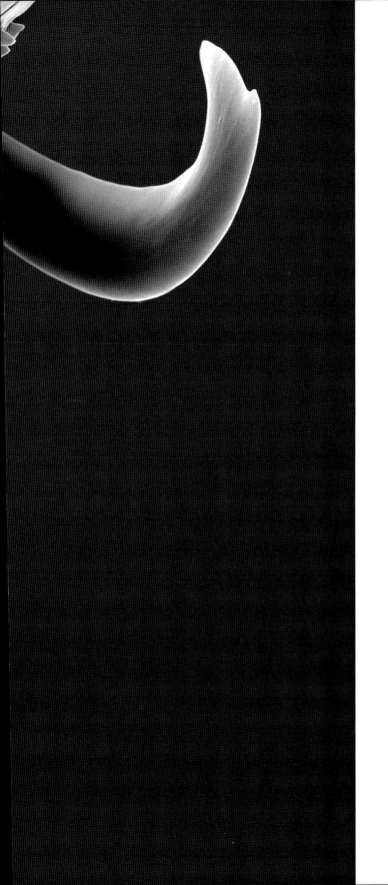

wing hooks 700x

A closer view of the hamuli

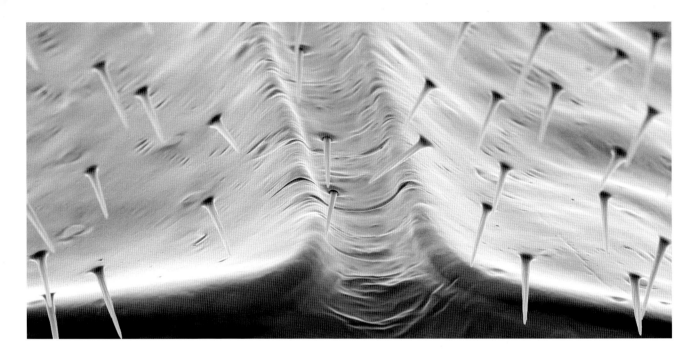

wing 800x (above)

wing 900x

The wing veins also serve as
structural supports.

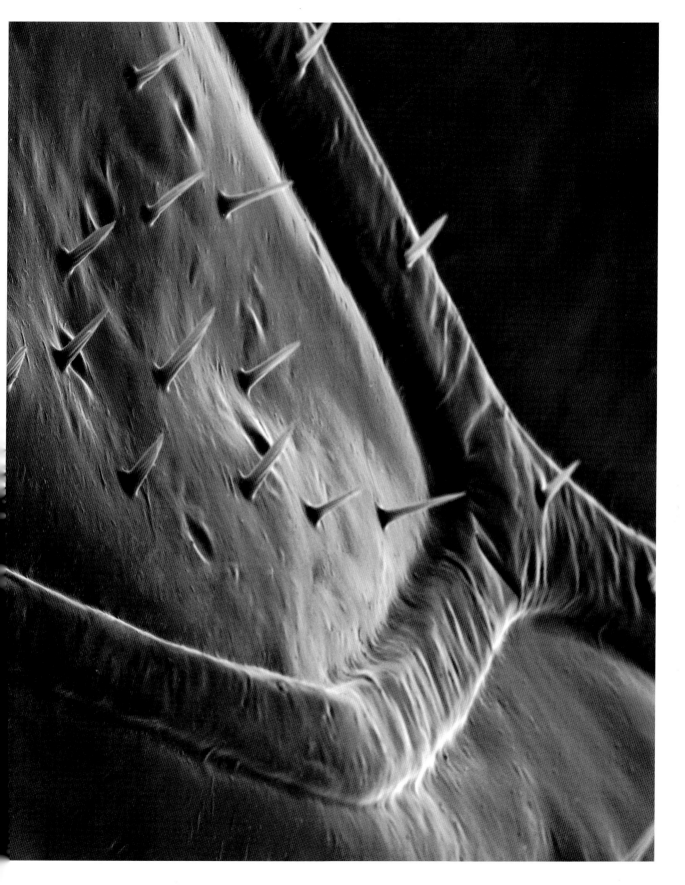

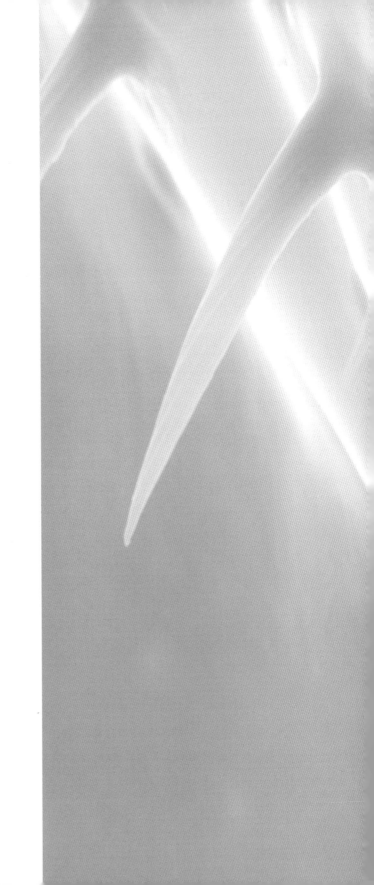

wing 1200x

ACKNOWLEDGMENTS

BEE came to be through the support and generosity
of many whom I wish to thank:

Stephen Harris, extraordinary and dear friend, at
Seal Laboratories, Los Angeles, without whom this
body of work would never have been possible.

The unparalleled, forward thinking Howard Stein,
whose immense and galvanizing generosity gave wings
to this book.

Jennifer Thompson, my truly wonderful editor, who
embraced the project and navigated it into existence;
Paul Wagner, the astutely creative designer of the book;
Dan Simon for his painstaking editorial work, and
everyone at Princeton Architectural Press who helped
bring this to fruition.

Sorche Fairbank, my remarkable agent and guide.

Jerome G. Rozen, Jr., curator and melittologist,
American Museum of Natural History, who helped me
find my way through the narrow constriction of
melittological complexity.

Ramon Martinez, beekeeper, Martinez Apiaries,
Los Angeles, and his photogenic bees.

Verlyn Klinkenborg, whose words draw us into the
spirit of the hive and make us want to stay.

I also thank Christina Salgo, catalyzing angel; Center/
Review Sante Fe, where the seed was planted; and
NAPPC and Pollinator Partnership at pollinator.org.

And my mother, my queen bee, whose love is
boundless; my father, whose ideals continue to influence
like pollen carried forward on a soft breeze; and my
brother, always close.

SOURCES

The captions in this book are meant to provide a small
window to the vastly intricate morphology of the bee,
as well as to extol the very terminology of their body
parts, words that to me are wonders in their own right.
I hope they will stimulate further exploration into the
work of experts in the field. I have been guided by, and
recommend the following books and online sources:

Frank Richard Cheshire, *Bees and Beekeeping,
Scientific and Practical V1: Scientific* (London: L.
Upcott Gill, 1886).

Hattie Ellis, *Sweetness and Light* (New York: Harmony
Books, 2004).

Eric Erickson, Jr., Stanley D. Carlson, and Martin B.
Garment, *A Scanning Electron Microscope Atlas
of the Honey Bee* (Ames, IA: Iowa State University
Press, 1986).

Lesley Goodman, *Form and Function in the Honey Bee*
(Cardiff, UK: International Bee Research Association,
2003).

Charles Michener, *The Bees of the World* (Baltimore,
MD: Johns Hopkins University Press, 2000).

R. E. Snodgrass, *Anatomy of the Honey Bee* (Ithaca, NY:
Comstock, 1984).

"Jan Swammerdam," *Encyclopedia of World Biography*
(Stamford, CT: Thompson Gale, 2004).
www.janswammerdam.net

Mark L. Winston, *The Biology of the Honey Bee*
(Cambridge, MA: Harvard University Press, 1987).

Various publications by the Carl Hayden Bee Research
Center of the USDA Agricultural Research Service:
(www.gears.tucson.ars.gov)

The Book of Nature; or *The History of Insects*;
(revised, English translation of *Bible of Nature*)
London: Printed for C. G. Seyffert, 1758
History & Special Collections for the Sciences,
Louise M. Darling Biomedical Library, UCLA